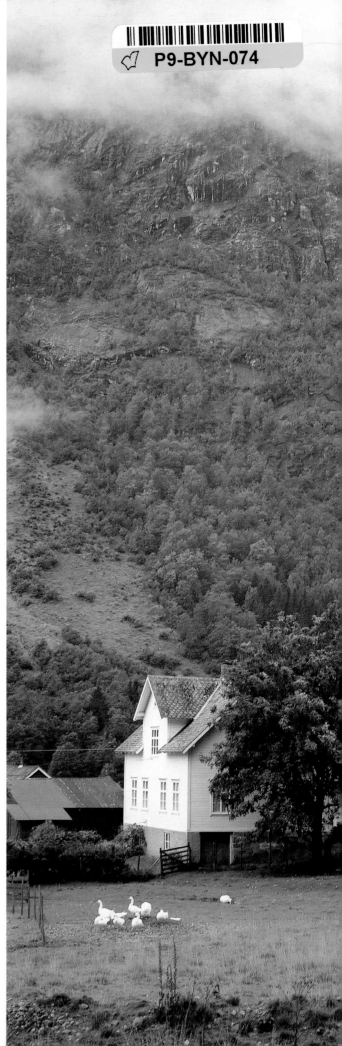

COMPOSITION TECHNIQUES

From a Master Photographer

Ernst Wildi

AMHERST MEDIA, INC. ■ BUFFALO, NY

Copyright ©2000 by Ernst Wildi
All photographs by Ernst Wildi
All rights reserved.

Published by:
Amherst Media, Inc.
P.O. Box 586
Buffalo, N.Y. 14226
Fax: 716-874-4508
www.AmherstMediaInc.com

Publisher: Craig Alesse
Senior Editor/Project Manager: Michelle Perkins
Assistant Editor: Matthew A. Kreib

ISBN: 1-58428-024-7
Library of Congress Card Catalog Number: 99-76583

Printed in Hong Kong
10 9 8 7 6 5 4 3 2 1

Notice of Disclaimer: The information contained in this book is based on the author's experience and opinions. The author and publisher will not be held liable for the use or misuse of the information in this book.

TABLE OF CONTENTS

Section Two
GUIDELINES FOR COMPOSITION

Section Three
ADDITIONAL COMPOSITIONAL TOOLS

INTRODUCTION

◻ Concerns in Composition

Whenever we take a picture with a camera, our first and main concern – sometimes our only concern – is to end up with a picture that is technically perfect, or at least acceptable without any obvious faults that distract from the enjoyment of the image. Therefore, the first requirement for success is learning what is necessary to achieve such results. There is little or nothing to learn with modern point and shoot cameras that make all the lens settings automatically, focus the lens automatically, decide whether you need flash or not and even set the flash for correct exposure if necessary. Our concern is practically limited to holding the camera steady when we make the exposure. While such automatic cameras leave little to our own control, they provide the advantage of giving us more time to study the subject, the lighting and the composition instead of spending our time worrying about technicalities. The technical quality of the images produced with such "camera determined settings" and "camera produced pictures" is usually amazingly good.

> "...find ways of recording the subject in the most effective way."

Producing a visually effective image requires more than technical expertise. First, we must have an eye that sees subjects or scenes that are beautiful, striking, different – scenes that others overlook. We also must have an eye for light. We must see scenes or subjects that are made visually effective by the existing light, or find ways to improve the light. Next, we must find ways of recording the subject or scene in the camera in the most effective way. We must decide how much of the subject or scene we want to record, from what angle the subject is recorded in the most effective fashion and also how the subject should be composed within the picture frame in relation to other subjects and in relation to the background. While some of the aforementioned points can easily be accomplished with a more sophisticated camera that has the necessary features and controls, they also apply and should be considered even when using an automatic camera.

When working with a camera that lets us decide and control the lens settings and the settings of other image creating features, we have many additional image creating possibilities. We can (and must) decide on the range of sharpness, the degree of background sharpness and background coverage, and the perspective, to name just a few. All these added possibilities that we have in better cameras must be used as part of

7

the image creating process in addition to composition. They must be discussed in combination with composition because images often can be made more effective with different approaches. Instead of eliminating a distracting element by changing the camera position, you might accomplish the same or better improvement by changing the lens setting or photographing at a different focal length. Whatever approach you may use to accomplish the goal, try to do it when you take the picture. Try to record in the camera an image that is as perfect as can be, assuming that nothing can be changed afterwards.

☐ Image Format Options

Naturally, the picture creating process is not necessarily finished when the image is recorded in the camera. There is one option that should always be considered afterwards regardless of the camera or film format in which the original was made. This option is changing the image format. Some subjects can be composed more effectively in a specific format, or a specific format may visually enhance an image. This is often the case even though the image looked good in the viewfinder. So, be open minded in regard to the image format. Never let the image format recorded in the camera or the format of the enlarging paper determine the format of the final image. In addition to changing the format, we have

other possibilities for changing an image afterwards, especially when producing the print in the darkroom and retouching the print.

☐ Digital Imaging

The "post exposure" possibilities have been greatly enhanced with electronic imaging. You can now improve images made in any camera in any format with electronic retouching. You can eliminate distracting elements, add elements, combine different images, change parts of an image or change images completely. The possibilities are limited only by your own imagination.

> "The possibilities are limited only by your own imagination."

These new possibilities for retouching images may perhaps bring the danger of some photographers becoming less careful and critical when recording the image in the camera, thinking and hoping that things can be changed and improved afterwards. While fascinating improvement possibilities exist, I still recommend that you spend your time in careful image evaluation when you take the picture and that you try to record a visually perfect image in the camera whenever possible. There are, of course, situations

when the picture must be taken instantly - when we do not have the time or the opportunity to completely evaluate the image and the composition. In such cases, the possibilities for improving the image afterwards offered by electronic imaging are appreciated, even if the improvement involves nothing more than eliminating a distracting element.

Electronic imaging is a fascinating addition to photography, and we have the wonderful opportunity of creating images photographically or electronically or combining the two in many different ways. It is completely up to us to decide to what extent it should be part of our photography.

Most photographers will probably continue to have the greatest enjoyment from creating the images in the camera, while others may obtain more enjoyment by working at the computer - perhaps converting snapshots into graphic illustrations. For most photographers, photographic technique will probably become a combination of the two. Regardless of your approach now and in the future, everything covered in this book needs to be considered at some point during the image creating process. All the suggestions about composition apply, regardless of how you create the image. The main difference may be in the term that we use for the final image. I feel that an image that has been changed electronically by more than minor retouching should

no longer be called a photograph, but rather an illustration. I like to limit the term "photograph" to an image that shows things pretty much the way they are seen with our eyes. If such electronically manipulated images are presented to other photographers in any fashion, the viewers must be made aware that electronic work has been done.

If you work as a professional photographer, this decision may not be completely up to you. Your client may decide whether a job needs digital work and to what degree it should be done electronically. Surveys have shown that clients – not photographers – are the primary drivers of the move to digital capture. Many clients are convinced that the digital process is faster and better. In the professional field, speed is the primary appeal for the digital approach. The client can see the image right away, and the images can go straight to retouching and the press. Since the image can be approved by the client immediately, you can break down the set immediately and prepare for the next job.

As a professional photographer, therefore, you must be prepared to discuss the digital possibilities and either know how to do it yourself or where to go to get the work done professionally. For instance, you don't need to become an expert in working with the Photoshop® software – there are specialists almost everywhere that can do this work for you. But you must know what can be done, so you can discuss it in a professional manner with your client.

While electronic imaging has added a completely new dimension to photography and makes the creation of visuals so much more exciting, my own choice is still creating images in the camera and creating them as perfectly as I can so they do not need any changes, additions or eliminations afterwards (except possible changes in the image format). I also want to show things as they are, not as I think they should be; as a matter of fact, I hope that my images show the subjects and scenes that I photograph more beautifully and more effectively than most people see them. I want to record my final and perfect image in the camera because that is what I enjoy, and that is what photography is to me.

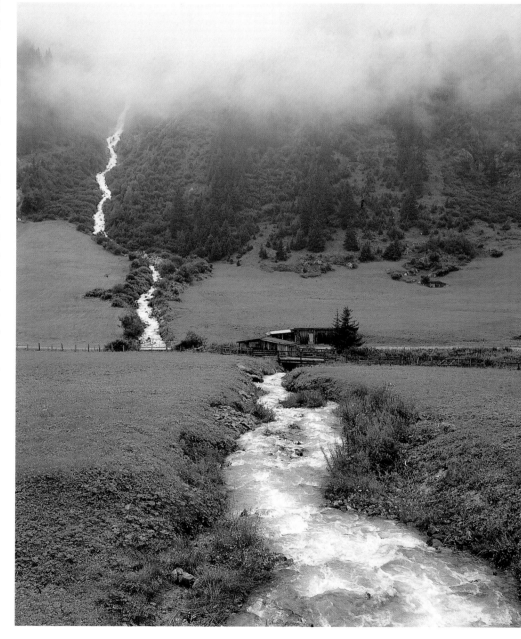

The stream, the only element in this picture, leads the eye from the bottom of the picture to the fog across the hillside. The fog enhances the mood of the image.

1

WHAT IS COMPOSITION?

■ The Basic Elements

Photographs are made for many different reasons and purposes. Some are made just for personal reasons – to record the events and happenings within the family, friends or business or to memorize the sights from our travels. Such images simply need to please you (the photographer) and bring enjoyment to those who may be recorded on the film or who may have travelled with you. Such photographs can serve their purpose well as long as they are technically perfect or at least acceptable (so that technical imperfections do not detract from the enjoyment of the image). Technical perfection involves anything from acceptable sharpness, or good exposure that produces decent or natural colors, to minor faults like slanted lines in an architectural photograph.

On the other hand, professional photographers must create images that not only please themselves but also the client

Fascinating images can be created by nothing more than an interesting arrangement of lines, shapes and colors – regardless of what the subject might be. Above, blistering paint on a old railway car. Opposite, an effective combination of vertical, horizontal and diagonal lines.

for whom the images are pro-duced. Technical perfection is not enough. Such images must usually also convey a message and/or sell a product.

Amateurs practicing pho-tography as a serious hobby or working in the field of fine art photography must produce images that please viewers who have no personal interest what-soever in the image. Technical perfection is not sufficient in this case. Such photographs must also be beautiful, unique and exciting – essentially, they must have a visual impact that inspires the viewers, makes them remember the image, and creates the desire to see the image over and over again. Composition is a major element in accomplishing the primary goal: getting your message to the viewer in the simplest, clearest and most effective way. At the same time, I also want to

point out that whatever is discussed under "Composition" is not a technical fact that must be followed in order to succeed. The suggestions must be considered as guidelines that help you create a good image. Once mastered, you are on your own, and you may want to create at least some of your images in your own style with your personalized composition.

■ **Additional Considerations**

In the mind of most photographers, composition simply relates to the choice, arrangement and placement of the lines, shapes, and dark and light areas within the picture frame. Choice of colors and the placement of the different colors within the photographic image are added to the above concerns in a color photograph.

When investigating such possibilities, don't be overly concerned what the subject is or limit your photography to specific subjects that are in themselves interesting. Look at the scene more from the point of view of a graphic designer. Search for subjects and use them as part of a design with a strong visual appeal. I have photographed brightly colored telephone booths, traffic signs, and even window displays simply because they formed an interesting design in combination with the background or the surrounding area. Silhou-ettes always make a strong design element. Your final image may then be not so much an image of a subject but a composition of designs and colors.

In addition to the aforementioned points that are generally considered part of composition, there are others not directly related to composition which are, however, equally important in determining the effectiveness of the final image. An image may have the perfect subject placement and arrangement of lines, shapes and colors but may include an unfocused, cluttered background area or a blurred foreground element that distracts and thus spoils an otherwise good image.

To me, composition is not just the placement of subjects, lines, shapes and colors, but everything else that affects the effectiveness and impact of the final picture – elements like the size relationship between subject and background, the range and degree of sharpness or unsharpness within the picture, the addition of attention creating elements or the elimination of distracting elements.

Composition includes everything that must be considered during the entire photographic process from the moment the image is evaluated in the camera's viewfinder to the presentation of the final image in a portfolio, frame, book, magazine or on the projection screen.

An ordinary, everyday subject may often display an interesting arrangement of lines, shapes and colors.

2

COMPOSITION IN THE DIFFERENT VISUAL MEDIA

◼ Photographic Medium

The basic elements that determine the effectiveness of the final image apply in all visual media – in a photograph or transparency, in a motion picture or in a video image. These elements also apply whether the image is recorded on film or created electronically.

◼ Digital Medium

If electronically created portions are added to an image created on film, as is frequently done today in professional and amateur images, the digitally created part may look different from the part created photographically. Since anything that is different in an image attracts attention, the digital portion that is visually different becomes the attention-creating element. This may be desirable, or may distract from the message that you are trying to convey in the image. If so, eliminate, change it or move it somewhere else within the image.

◼ Videographic Medium

In a motion picture or video, you must also pay attention to moving elements. A viewer's eye is always attracted to anything that moves – even if it involves nothing more than a leaf falling from a tree or a cat walking in the distance. This is true especially when such a subject is the only moving element within the picture frame. Even the slightest moving element may distract from the message we are trying to convey in the image.

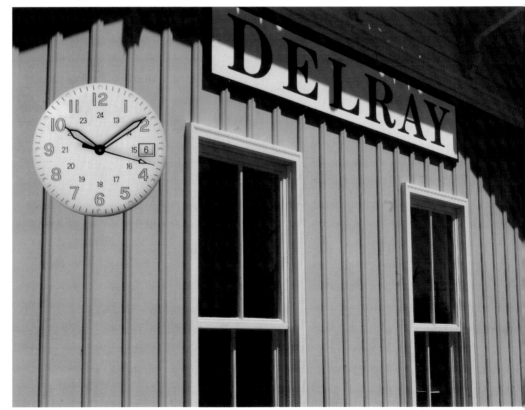

The eye is attracted to the clock because of its different graphic design. The clock was added electronically to the photographic image of the railway station.

3

COMPOSITION AND PURPOSE OF IMAGE

■ Determining Purpose

In some cases, composition is determined by the way the final image is to be presented or used. This is true especially in the commercial field of photography, where the image must fit a specific layout decided upon by the art department and where the image is not used by itself but is combined with text.

In this case, the composition of a photo cannot be based completely on the way it looks as a photographic image. It must also be determined by the impact it creates when presented in the final version combined with text, and other images or sketches. The placement of the main subject, for instance, may have to be in a different area where it best serves its purpose in the combined presentation.

■ Format of Image

The composition, of course is always also determined by the format of the final image: square, rectangle or panoramic.

To say it in a different way, the desired or necessary format of the final image must be considered when the image is created and evaluated in the camera's viewfinder.

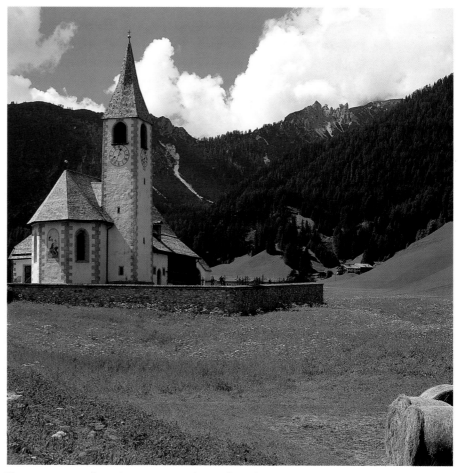

The purpose of an image may determine the composition. The image of the church alone (opposite) is a typical tourist view and excellent for a picture post-card. For a personal image, you might choose to include the bale of hay (as above) in your composition.

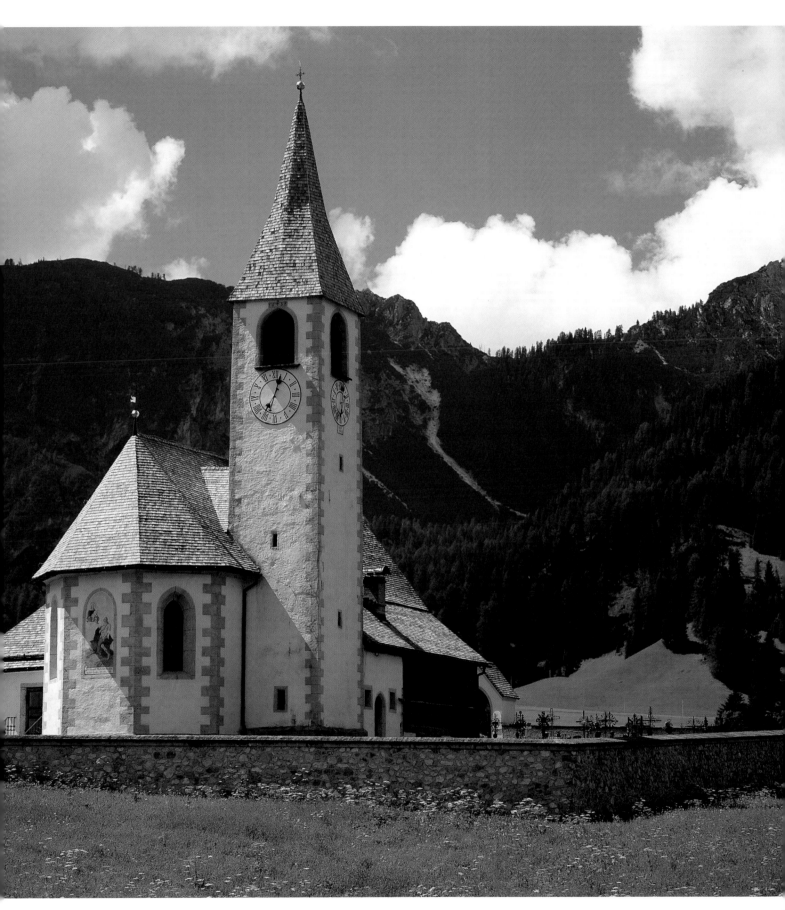

4

COMPOSITION AND IMAGE FORMAT

■ Composition Related to Image Format

Composition is directly related to the format of the final image. In my mind, and contrary to general belief, the basic rules apply in all formats. For example, subject placement is basically the same whether the final image is rectangular, horizontal, vertical, square or panoramic. Naturally, each format has some special requirements that result in the most effective image, but the basics do not change. You need not re-study composition if, for instance, you move from a camera that is designed for rectangulars to one that is designed for squares.

■ Selecting the Image Format

Sometimes you have a choice in determining the image format, and sometimes you do not. For example, the format may be pre-determined by the way the image is used. If the image is used on the cover of a magazine, it probably will have to conform to the format of the magazine. An advertising image will have to conform to the layout of the art director. Our own choice may be limited when the image is used for projection, or needs to be presented in a special form. In motion pictures or videos, we have no choice at all. The image must be horizontal and correspond to the format for which the camera is designed.

"...produce the image in a shape that adds the proper impact."

For most of our personal work, fortunately, the format choice is usually wide open. In such cases, the most effective image is achieved when the image format is directly related to the subject or to the message that we are trying to convey in the image. This goal can be accomplished in two ways.

First, we can pre-determine the image format (for example that it must be a square) and then produce the most effective arrangement of the elements and colors within the square when visualizing the image in the viewfinder of the camera. When photographing a 35mm transparency, we may pre-determine that it should be projected on the screen in the horizontal format, and then compose it in the viewfinder as an effective horizontal.

As a second option, we may simply photograph a subject as it looks best in the viewfinder without necessarily considering a specific image format, then change its shape later and produce the final image in a shape that adds the proper impact.

The change of shape can be made during printing or by masking the transparency when it is glass mounted. This second option is a common approach for me working in the square format – as it is for wedding

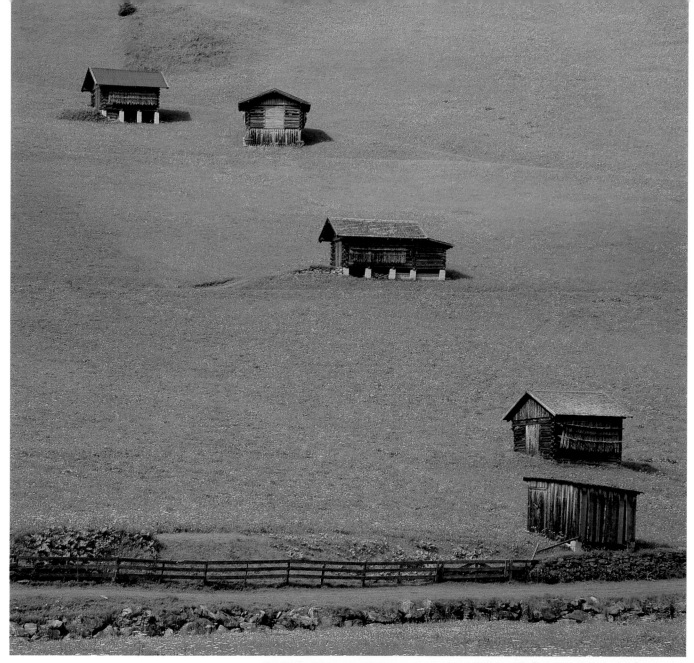

Squares and rectangles are beautiful image formats that should be always considered for the final image. In the image above, the farm buildings arranged diagonally on the hillside fill the square beautifully from top to bottom and left to right. The rectangular shape enhances the horizontal repetition of the motorcycles in the image to the right.

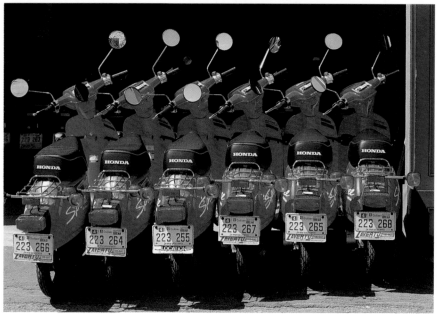

photographers working with a square medium format camera. All images are produced as squares, then frequently changed into rectangular horizontal or vertical images afterwards. The convenient and practically unlimited possibilities of changing the image shape afterwards is my main reason for working in the square format.

■ Image Format and Paper Format

Some medium format camera manufacturers have promoted the rectangular 6x4.5cm and 6x7cm formats as the best medium formats simply because they correspond more or less to the rectangular sizes of enlarging papers. They even refer to the rectangular 6x4.5 and 6x7 sizes in the medium format as "ideal formats." I consider this viewpoint most unfortunate. It may narrow the creative viewpoint of the photographer who thinks of the paper size instead of the image when composing in the viewfinder. Image format must be related to the image itself or the use of the image, not the size of the paper that comes from the manufacturer.

■ Rectangular Images

The rectangle is the most popular image shape in photography and in art because it provides the choice of making the images as verticals or horizontals. Because of the different length of the two sides, rectangular images are considered more dynamic than squares. Enlarging papers are made in the 4x5 aspect ratio such as 8x10" (20x25cm) or 16x20" (40x50cm). This paper ratio corresponds closely to 6x4.5cm images produced in the medium format. The 24x36mm images from a 35mm camera produce a longer and narrower

The aspect ratio of the 35mm frame does not correspond to that of standard enlarging paper (8"x10", 16"x20"). You must crop 6mm off the long side to match the image to the paper format. You may wish to keep this in mind when composing the image in the camera.

In a square format camera, you can compose your images as squares, horizontals or verticals without having to turn the camera. After shooting, the square frame can be printed as a rectangular horizontal or vertical. Such a change does not reduce image quality. You are not cropping (enlarging a small area of the negative) but simply changing the shape, leaving the long side of the negative at its original length.

image in the 2x3 aspect ratio. The 35mm photographers must realize that the images produced on the film must be cropped 6mm along the long side for printing on the standard enlarging papers. You may want to keep this in mind when composing in the 35mm camera. I personally prefer the 4x5 ratio for most images over the 2x3 ratio of the 35mm camera.

■ The Square Format

The equal lengths of the two sides give the square a pleasing, harmonious quality. Although the square format goes way back to the Box Brownie cameras and has been the most popular and only medium format for many years, it is still to this day sometimes considered a non-standard size. Some photographers are reluctant to buy a camera that is basically designed for producing square pictures. This is unfortunate, especially since the feeling is often based on misinformation. The image format recorded in the camera needn't have any-

thing to do with the format of the final image.

The format of the final images is (and must be) a personal choice of the photographer – or must be related to subject, or the use of the image. The camera choice should have nothing to do with whether one likes the square image or not, because the format of the final image need not be directly related to the image format recorded in the camera (especially not when recorded as a square). The final image need not be square.

> "A square gives you complete freedom..."

A square gives you complete freedom and opportunity to change the image into a vertical or horizontal, and you can make this change later when you have time to evaluate the

different possibilities. You can also do this without losing sharpness. You are not cropping, but only changing the shape of the image and leaving the long side at its original length. For example, when changing a 6x6cm image into a rectangle, its long side is still its original length. We simply trimmed the image on the sides.

To these practically unlimited image shaping possibilities must be added the convenience and speed in shooting with a square format camera. The camera is always held the same way and sits on the tripod in the same fashion, freeing you from having to spend time deciding whether the image should be a horizontal or a vertical.

Added to the wonderful option of changing the shape of the square, you have the other option of producing the final image as a square with its harmoniously related dimensions.

■ Framing the Square Picture

Picture frames in the square format are not as readily available as in the rectangular sizes, at least not in a general framing shop. They can, however, be obtained from various framing manufacturers that supply frames to wedding and portrait studios. There is no rule that a square photographic image must be in a square frame. A square photograph can be very effective in a vertical rectangular frame, matted to leave the same margin on the top as on the two sides and a wider margin at the bottom. This approach is frequently used on advertising pages where a square image on the top leaves sufficient space at the bottom for the advertising message.

While white matting is usually used in gallery exhibits, I do not recommend it for color or black and white photographs. The white is extremely bright and distracts from the photograph. White is a poor choice for color prints. Select a dark grey or darker color, even black, which is a frequent choice for printed camera literature. Doing so allows the color images to stand out.

■ Image Format for Portraits

While the basic rules of composition apply when photographing people, some special comments should be made about composition for portraits if only because portrait photography is an important field for many photographers and may even be the only field of photography for many professionals.

Portrait and fashion pictures, especially three-quarter and head-and-shoulder types, can be effectively composed in the usual vertical rectangular format, or as a square. The square can be an especially good choice when the portrait includes other elements (hands for example). If the person looks somewhat towards one side, rather than straight into the camera, it is usually best to leave more space in the viewing direction in any format. But I have also heard the comment that you may want to reverse this statement when photographing a very old person. Leaving less space in the direction of sight may emphasize the age of the person, as if there are fewer years in his future than there were in his past.

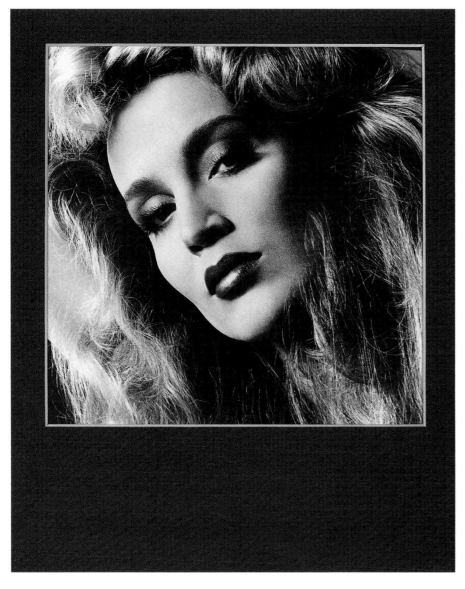

Square images, properly matted and spaced, can be effective in a standard rectangular frame. Square images do not necessarily need square frames. Original photograph by Douglas Dubler.

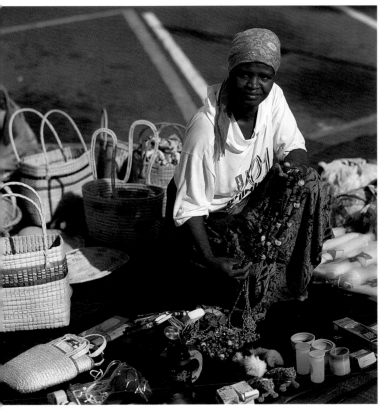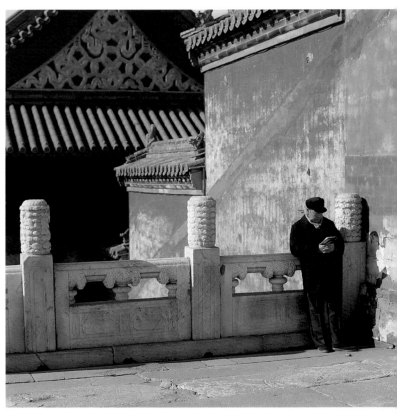

The background and surrounding area must be a dominant part of an outdoor portrait, giving it the true location look. This applies to both formal portraits and candid people pictures. In the photo on the left, the square format allowed the inclusion of a large number of the goods this lady was selling in Durban, South Africa. In the photo on the right, including a portion of the architecture from the Imperial Palace in Beijing leaves little doubt about the location of the reader's portrait.

■ Image Format for Outdoor Portraiture

The vertical rectangular format is usually the first and logical choice for full length portrait and fashion shots. It is the best choice for studio portraits shot in front of a plain backdrop, but not necessarily so for people pictures at outdoor locations. An outdoor portrait should be more than than just a picture of a person; it should be an image of a person combined with an image of the location. That is the reason for doing it on location instead of the studio. In a successful outdoor portrait, the setting must become an important part of the image and must enhance the mood and feeling of the image. The type of background and the amount of background area to be included must be carefully chosen. You also want to give serious consideration to the degree of sharpness in the background. Rather than producing a complete blur, you may want to maintain some sharpness to make the background at least recognizable.

> " ... the setting must become an important part of the image..."

You may also want to select the image format carefully, and you may very well come to the conclusion that the square is better than the rectangle. The square format allows you to include more background area on the two sides without decreasing the size of the person. The square allows you to make the surrounding background area an important part of the image, and makes the picture a true location portrait. This is one field of photography where I feel that the square has a definite advantage over the rectangle.

The desire to make an outdoor portrait look like a real location portrait is the reason why many successful professional photographers today use wide-angle, extreme wide-angle

and even fisheye lenses for location portraiture. These short focal length lenses allow them to include more of the background while maintaining the size of the person.

■ The Panoramic Format

The panoramic format is also rectangular, but with an aspect ratio of 1:2 up to 1:3. The long dimension is twice to three times as long as the other dimension. The unique aspect ratio of this kind of image is undoubtedly one reason for its effectiveness. We are so used to seeing images in the square format or a rectangular in the 4:5 aspect ratio that anything that is different attracts attention. You can perhaps look at panoramic images as a combination of a wide angle and a telephoto shot – a wide angle in one direction, a telephoto in the other.

The wide or high format allows you to emphasize the space and expanse of a landscape, beach or mountain range or the height of a waterfall or redwood tree. The panoramic format can enhance these aspects beautifully because you do not need to include many elements on top and bottom (or on the two sides in a vertical) which might distract the viewer from the feeling that you are trying to get across.

Since our own vision is panoramic, we might feel that it is easy to create good panoramics or that anything we photograph in this format will result in an effective image. This is not

so. Subjects must be selected carefully and the panoramic composition must be critically evaluated in the viewfinder, perhaps more so than images in any other format. A panoramic image must always convey the feeling that it must be a panorama, as if it could not be effective in any other format.

■ Image Format for Slide Projection

If transparencies are projected on a screen as individual images with one projector, they can be in the vertical, horizontal or square format and can be intermixed within the presentation.

If slides are used for more professional presentations, using two or more projectors to make the images dissolve into each other, you need to consider the image format more carefully. A slide presentation is more professional and more effective when each image projected on the screen fills the same area of the screen or (even better) the full area of the screen (as in a motion picture). "Avoid mixing horizontals and verticals," advice that you will hear from every professional audio/visual producer. When mixing verticals and horizontals, remember that the two cover two completely different areas of the screen. Neither the horizontals nor the verticals fill the entire screen. Horizontals leave an open space on the bottom and top; verticals do the same on both sides. Throughout the presentation, the audience will be more aware of the picture format than the image that

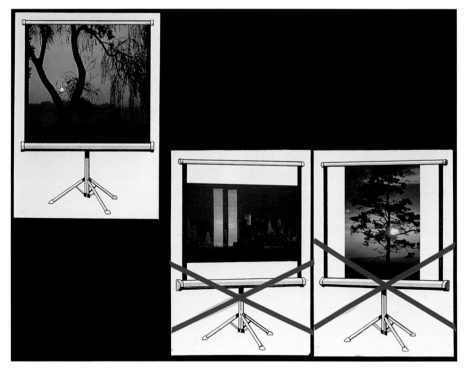

Square images are perfect for slide presentations since every image fills the entire screen area (left). When mixing horizontals and verticals, we leave empty areas on the screen which make the audience more aware of the image format than the images we are trying to present.

Changing the shape of the image can often improve its effectiveness by eliminating excess space (left), placing the main subject in a better space within the frame (right), or eliminating distracting elements (center).

you are trying to present. This distraction takes away from the enjoyment as well as the effectiveness of the visual presentation.

The image format must be seriously considered, especially when the presentation is also accompanied by a recorded soundtrack. With the addition of recorded sound, the audience expects something more professional, and mixing verticals and horizontals is just not professional.

For a most effective and professional presentation with 35mm slides, project only horizontals so that each image dissolves into the next in a smooth, motion picture-like fashion. You may want to consider this point before shooting the images to be used in such a presentation.

Slides in the square format are unquestionably the perfect choice for a professional slide presentation. The square format is a beautiful compromise between the horizontal and the vertical since it provides the greatest and easiest opportunities to compose any subject, tall or wide, in the most effective fashion. You can then present the results with each image, not only filling the same area on the screen but the entire area of a square projection screen.

■ Changing Image Format to Improve Composition

If the image format is not pre-determined and is changeable, keep an open mind to the possibilities of improving the image by changing the format during the entire image evaluating process. Eliminating distracting or unnecessary ele-

ments from the image (especially the background areas) can often be achieved simply by changing the format and is probably the main benefit of this process.

I often change a square into a vertical rectangle in candid pictures of people. To capture the people with their natural expression, sometimes before they become aware of being photographed, I have to work fast. There is usually no time to move around, look for different camera angles that might include a better background area without distracting elements. While I try to eliminate such distracting elements directly behind the person, I am generally not too concerned about such elements in other areas of the frame because I know that I can eliminate them later by changing the square into a vertical.

"There is usually no time to move around..."

Changing the image format can be especially helpful in 35mm. While a horizontal 35mm image can hardly be changed successfully into a vertical, a vertical or horizontal 35mm image may be improved by slightly reducing the long side to eliminate unnecessary elements on the sides, top or bottom. You can reduce the long side by at least 6mm and still end up with a pleasing rectangular image in the standard 4:5 paper proportion.

In any format, watch carefully for bright elements, lines and shapes that may go into the picture frame. They can be very distracting.

The square format (right) with its additional space on the sides, compared to the vertical rectangular format (left), is excellent for outdoor people pictures because it makes the background a more dominant part of the image. This makes the portrait a true location picture.

5

LINES IN THE COMPOSITION

Guidelines for Composition

The elements that make up the composition can be broken down into lines and shapes, as well as grey, black and white areas in a black and white photograph or colors of different shades in a color image. They must all relate to one another within the picture to form a harmonious arrangement that keeps the eye within the picture frame. The principles of composition are easy to learn, and you will quickly be at a stage where these guidelines come to your mind automatically. You will start to see good compositions even before you look into the viewfinder of your camera.

Direction of Lines

Images consist of all types of lines – straight, curved, zig-zag and those going in all different directions. The direction of major lines can influence the mood and feeling that an image conveys. Horizontal lines in any image format are restful; they convey feelings of peace and quiet especially when a number of lines go horizontally and/or when the lines cover a large portion of the image area. If tranquility is the feeling that you want to convey (effective and appropriate in many landscapes), try to compose so that horizontals are dominant in the picture. The feeling can become even stronger if the image format is also horizontal and stronger still if it is a panoramic in the horizontal direction.

"Images consist of all types of lines..."

Vertical and diagonal lines are more active and tend to convey more the feeling of motion. They make images more dynamic, especially if there is a repetitive pattern of lines such as in a wooded area with a large number of tree trunks, or in a display of hanging Christmas ornaments in a market place. Paying attention to the direction of lines can help produce an image that is more appropriate to the mood and feeling that you are trying to achieve. Diagonal lines can be used effectively for leading the eye towards a main subject. For those of us who read from left to right, such diagonal lines are strongest when they go from the lower left to the upper right.

Curved lines can beautify an otherwise ordinary image. The existence of beautiful curved line patterns in a road or stream is often the reason why we take such pictures in the first place. This is especially true for the S-curve often found in a road or stream pattern. A curved line could also form a circle, sometimes considered the most beautiful compositional shape because it symbolizes eternity.

While the direction of the

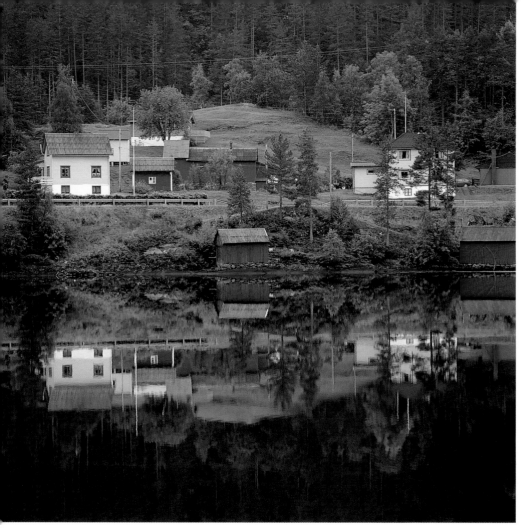

lines is usually pre-determined by the subject we are photographing, we also have possibilities of changing the direction and producing a better, more moving image.

◻ Creating Diagonals

When a subject with horizontal lines is photographed straight on, the lines will also appear horizontally in our image. They can be changed into more moving diagonals in two ways.

Instead of photographing straight from the front, photograph the same subject from an angle and the horizontals become diagonals, a straight fence becomes a fence going from the lower left to the upper right or vice versa. The amount of slanting of the horizontal is determined by the camera angle (how far to the side we move) and the focal length of the lens. A shorter focal length from a shorter distance will increase the effect. This approach can be used with any subject and changes only the direction of the horizontals, leaving the verticals perfectly vertical.

Horizontal and/or vertical lines in a subject can also be turned into diagonals by tilting the camera when the image is recorded. The same result can

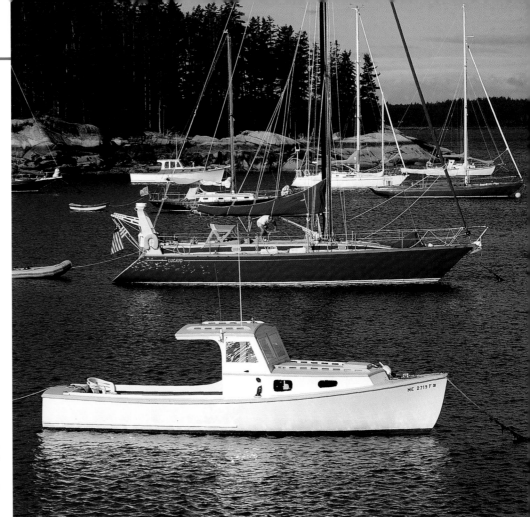

be achieved afterwards when a print is made by turning the paper under the enlarger. However, this is not possible without also losing part of the image, so it is better to consider this approach when taking the picture. Tilting the camera turns both the horizontals and the verticals in a composition. This approach must therefore be applied more carefully as it can easily look artificial and inappropriate.

Composing a subject so its lines are diagonal can produce a more visually striking image of static objects such as a church steeple, a statue or a tree. Composing the steeple, statue, or tree going from the lower left to the upper right corner produces a more dynamic image than one with the same subjects going straight up and down in the frame. Composed diagonally, the subject also makes better use of the picture format, whether the format is a rectangle or a square.

Images created with a tilted camera must look natural. This is usually the case when lines appear tilted in one direction only (usually vertically) such as the church steeple, a skyscraper or a single tree. When the image also includes lines in the other direction like the horizontals of a horizon, the result looks more like a special effect, attracting unnecessary attention. This would be the case for

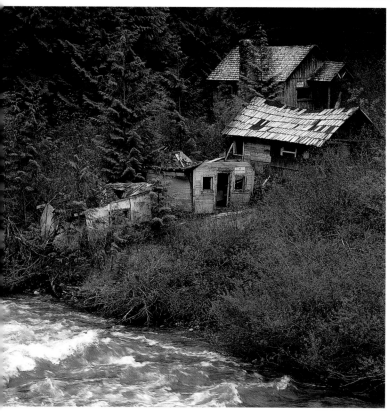

In the left image, the stream and broken-down houses in British Columbia were composed to form two diagonals going in different directions. In the harbor view of Nova Scotia (right) the main line is diagonal, leading the eye to the boat which, as the only horizontal subject, becomes the main subject.

The horizontal lines of a building can be re-composed as diagonals by photographing the building from an angle, rather than straight on.

instance, in a picture of an entire church or any other building photographed from the ground up. The tilted camera approach is often used in skiing and mountain climbing pictures. It can make a slope or the side of the mountain appear much steeper than it actually is. Compose such tilted images so they do not include the horizon or any other typically horizontal or vertical subjects like trees. Including these in the picture would give away the trick that you used.

The results produced by a tilted camera can also work well with special subjects (rides in an amusement park, perhaps) where we may want to create the feeling that things move in many different directions.

■ Placement of Lines

A strong horizontal or vertical line (such as the horizon or a tree trunk) placed in the center of an image in any format has the tendency of splitting the image into two equal halves. This usually does not work to your advantage. It makes our view jump from left to right (or top to bottom), not knowing which side is more important and where to stop.

The disturbing effect is enhanced when such lines

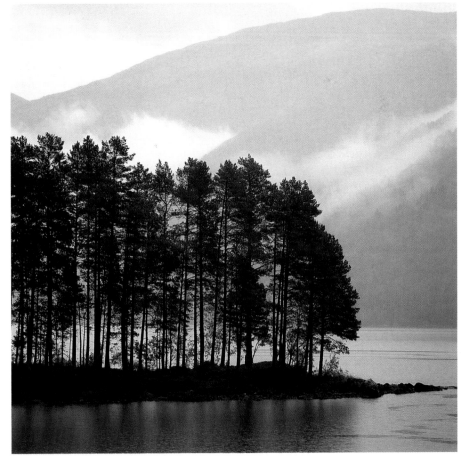

When photographing a stream or similar subject from above, compose it so the stream runs toward one corner of the image (top). Horizontal lines were effectively placed in the lower part of this image from Norway (bottom).

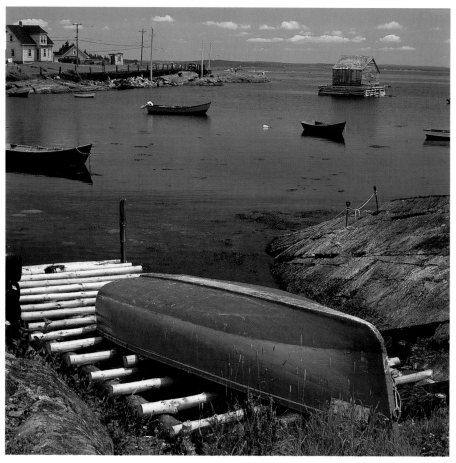

The horizon is placed at the top of this image to emphasize the colorful foreground.

cross the entire image area, as is usually the case with the horizon. One also becomes more aware of the "split image" when such a line crosses the long side of the image (the horizon in a horizontal, a tree trunk in a vertical). Placing the horizon in the center of the image practically never works, not even with a beautiful sunset or when the sky is filled with beautiful clouds. It is, in my mind, completely unacceptable with a plain blue or grey sky.

Since in a "center line composition" the viewer never knows on which side of the line to look, we must make the decision for him. We can do this by using a different composition, where a dominant horizontal (such as the horizon) is moved towards the top or bottom, or a dominant vertical is moved towards the left or right. The selection depends on which side of the image (top, bottom, left or right) is more important. In a sunset picture, you probably want to place the horizon towards the bottom to show the beautiful cloud formations in the sky. In a picture that is to show the vast extent of a landscape, you want to relegate the sky area to the top portion of the image. Exactly where within the picture frame such horizontal or vertical

lines should be placed depends on the rest of the image. You can, however, hardly go wrong by considering a position about one third from one of the frame lines.

This suggestion works well in most images, but there are exceptions. There are cases where a strong dividing line directly in the center is most effective. I almost invariably use this approach in scenes where subjects are reflected in the water. Placing the dividing line (in this case the line of the water surface) directly in the center seems to emphasize the repetition between the actual subject and its image in the water. This, I feel, is most effective in this case. I could also visualize a tree trunk directly in the center if there is a repetition on the left and right side – perhaps two smaller identical trees, or two identical houses in the distance on both sides of the tree.

These examples clearly show that anything discussed under the topic of composition should never be considered as a "rule" that must be followed to be successful. These points are suggestions that usually work and will help you produce an image that is pleasing for your own enjoyment and for your audience. However, your personal viewpoint and the effect that you are trying to achieve must determine the final decision on how the various elements are to be combined in your picture.

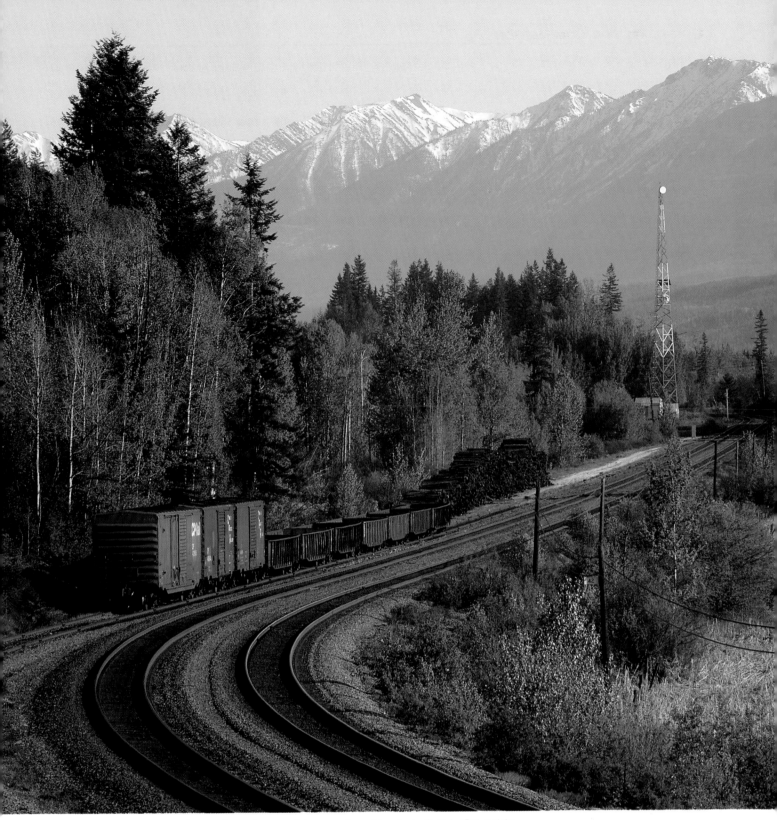

Curved lines help make an interesting picture of these railroad tracks in British Columbia.

■ Curved Lines

Curved lines can be almost anywhere in a picture but are usually most effective if they start at the lower left or right corner, not in the center, then go diagonally into the scene. Our eyes have a tendency to follow a curved line into the picture then stop at the end of the line. Consequently, such images are most effective if there is some subject at the end of the line that is worth looking at, giving the eye a reason for following the line.

■ Importance of Lines

Any line that goes in a different direction from most or all others in the picture is likely to create attention. In a color image, a line of a different color attracts attention. We must be aware of this fact for two reasons. First, we can use such lines as an attention-creating element. We can perhaps compose the image in such a way that the lines of the main subject go in a different direction than the rest. We can also use such lines for leading the eye towards the main subject. This purpose can be accomplished with curved or straight lines, but they must have a different shape or color or must go in a different direction. The S-curve has always been popular for this purpose.

We must also be aware of the fact that lines going in a different direction can also be distracting, and can lead the eye to an unimportant part of the scene – or can even become the main attention creating element. The point where two lines going in two different directions meet usually becomes a point of importance and attracts the eye.

■ Distracting Lines

Watch the direction of lines when making the composition. Avoid dominant lines going in a different direction if they are distracting or unimportant – and especially if they lead the eye to an insignificant area within the composition. You can usually accomplish this with a different composition that may perhaps hide the line behind the main subject.

Watch especially for dominant lines or subjects going into the border of the image on any of the four sides. The point where the line or subject crosses the border creates unnecessary attention. If the line or subject is of a bright color or shade, the crossing point may even become the center of attention. It may also make the viewer's eye leave the picture completely which is the last thing that you want to happen to your photograph.

Vertical or horizontal lines that are seen as verticals or horizontals in nature must usually be recorded that way in the picture if they are not to be distracting. The most typical example is the horizon. Slanted, even to a slight degree, it creates attention and is distracting in any picture. The effect becomes more pronounced in a horizontal or in the panoramic format.

With any camera, in any format, watch the horizon line carefully when composing the image in the viewfinder. Adding

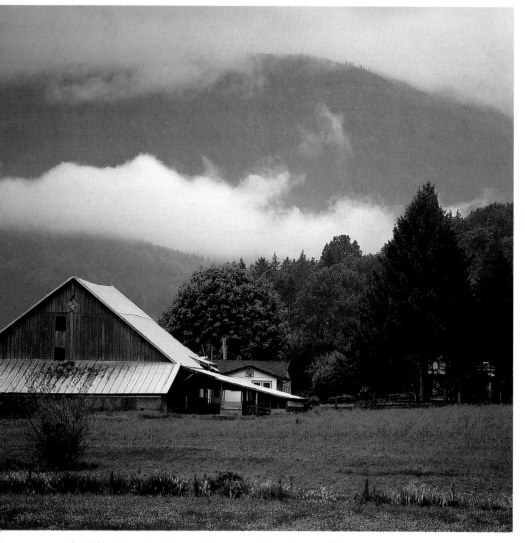

In this otherwise tranquil composition, the roofline attracts attention as it is the brightest and only diagonal running subject.

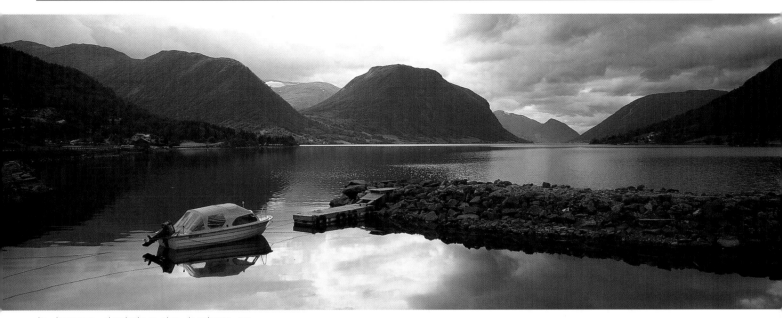

In images depicting the horizon or water surface (above), the line must be perfectly horizontal if it is not to be distracting. This is especially true in panoramics. In architectural images (right) slanted verticals created for the sole purpose of getting the whole building in the picture are distracting, and unacceptable like any other technical fault.

horizontal lines to the focusing screen can help. Screens with such engraved lines are available for some cameras. When working with a tripod-mounted camera, a spirit level can help, especially when composing landscapes in a panoramic camera.

If the horizon is slightly tilted on the film, it can also be straightened out when printing or when mounting the transparency. If you mount the transparencies yourself, be sure that the horizon in the image is perfectly horizontal in the mount.

■ Architectural Pictures

The most typical verticals that we recognize as "must be verticals" are the lines of a building. These straight vertical lines must be recorded as parallel, straight verticals – otherwise they may be as disturbing as a slanted horizon.

With architectural photos, you normally want to include

Cameras can be tilted if it is obvious that it was done to create a special effect or composition.

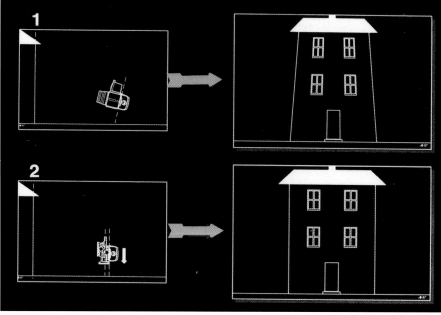

The vertical lines of a building are recorded parallel to each other if, instead of tilting the camera (top), the film or lensplane is shifted, keeping the film parallel to the building (bottom)

the entire building. A picture of a building cut at the top usually does not look very good, unless the building includes an obviously important or beautiful element that conveys the feeling that this element was the reason for taking the picture.

Photographing an entire building is not always easy. We frequently have no other choice than tilting the camera in order to include everything from top to bottom. Tilting the camera, however, results in slanted verticals which I find disturbing in any picture of a building, not only in a professional architectural photograph.

I can accept slanted verticals in a building only if it is obvious that they were created purposely for effect, or because they look natural. For example, the vertical lines in a skyscraper are slanted whether we view the building with our eyes or photograph it from street level with a camera. The slanted lines of a church steeple or a skyscraper look natural in a picture because we also have to tilt our head to see the steeple or the skyscraper, and with our head tilted the view with our eyes is pretty much the way the building or the steeple looks in our photographic image. Photographically, we can enhance the slanted lines by using a wide angle lens.

On the other hand, when the slanted lines in a building are created only by the photographer's desire to get the entire building into the picture, it often appears to me as a techni-

Travel pictures of well-known tourist sites look much more professional with straight verticals accomplished through perspective control.

cal mistake and distracts from the enjoyment of the image. Try to avoid slanted verticals even in your travel pictures of the exterior or interior of beautiful or historic buildings.

■ Straightening Verticals

Vertical lines such as those of a building are always recorded straight and parallel when the film plane is parallel to the building, a principle known to every architectural photograph-er. Sometimes, using a wide angle lens can help to accomplish this goal, especially when the opportunity exists to photograph the building from a higher angle, perhaps from a window across the street. If the

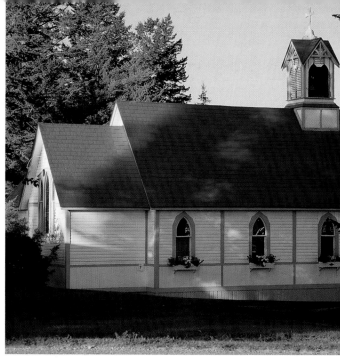

Slanted verticals in a building can sometimes be avoided by shooting with a longer focal length lens from a greater distance (above). The longer distance reduces or eliminates the need for tilting the camera. In the image on the right, the church was shot from a greater distance and with a telelens three times longer than standard in order to avoid slanted verticals.

picture must be made from the street level, a wide angle lens frequently does not help, because the composition will also include a large (usually undesirable) foreground area.

When you have the opportunity to photograph the building from a greater distance, try to accomplish this goal using a longer focal length lens. The longer focal length may allow you to cover the entire building from a longer distance and without tilting the camera much or at all. When neither of these approaches work, you have to resort to special equipment.

A large format camera where the film and lens plane can be tilted and moved up and down in relation to each other is one solution that has existed for years. The best approach (used by professional architectural photographers) is as follows. First, set up the camera with the film plane parallel to the building, then shift the film or lens plane up or down until you cover the desired area (the building from top to bottom). In shifting, the lens and film plane remain parallel to each other and maintain sharpness.

> "...place the film plane parallel to the building..."

Today, you need not move up to the expensive and time consuming large format approach. Special camera bodies built around a bellows are available for rollfilm in the medium format. Several solutions exist, with the Hasselblad Arcbody being the one that I have used for some of my work. In the medium format and in 35mm, straight and parallel verticals can also be produced with PC (perspective control) lenses or PC teleconvertors. Such lenses, or convertors combined with a ordinary wide angle lens, have a larger covering power than needed for the camera's image format. The lens, or lens and convertor combination, can consequently be shifted up or down without vignetting in the image. Instead of tilting the camera to cover the building all the way to the top, we move the lens, or lens and convertor combination only, keeping the film plane parallel to the walls of the building.

Since slanted verticals are so disturbing to me, I feel it is worthwhile carrying such a PC lens or PC convertor, if available for your camera, on your travels.

Perspective control equipment allows you to produce better and more professional looking images of the many interesting, beautiful masterpieces of architecture that exist everywhere in the world.

6

SUBJECT PLACEMENT

■ Type of Image

A photographic image, as any other image, must create attention, and must keep the eye within its boundaries. The viewer's eye should never make any attempt (or have the desire) to go beyond the image area, regardless of the format of the picture. Careful composition can accomplish this goal, achieved mainly through effective subject placement.

Good images are usually made up of one main subject – perhaps complemented with secondary, less important elements. Good images can also be created with nothing more than a repetitive arrangement of identical or similar shapes and colors over the entire image area without one specific main element. We can, perhaps, say that such an image has no beginning and no end but can be full of life. Good examples of this type of image include: a bed of flowers; a summer meadow with different colored grasses; weeds and flowers; a hillside with rows and rows of fruit trees; sand dunes in a desert or an image of fall colors with nothing more than brown, yellow, red and green leaves filling the frame from top to bottom and left to right. The effectiveness of such images is created by the repetition of the same or similar elements and/or colors within the picture frame. The main compositional requirement is achieved by having the different elements and/or colors spread in an effective fashion over the entire image area, creating a visual balance.

"Careful composition can accomplish this goal…"

Most other images can or must be enhanced visually by including one main subject, which then becomes the focal point of the image. The image of the flower bed, for example, could include one dominant rock. The image of the sand dunes could include a figure or parts of an old broken down wagon. The image of the fall trees could consist of all yellow trees with the exception of one that is bright red and then becomes the main subject. Placement of this main subject and placement of secondary elements within the picture frame must now become the main consideration.

■ Placement of a Single Subject

When a single subject is photographed in front of a plain studio background or an outdoor background without any other attention-creating elements, the most effective subject placement is usually in the center of the image. Examples for center placement include a single building, a product in an advertising illustration, a vase of flowers with the flowers bending in all different directions, or

Since the person in the portrait on the left (above) was looking straight into the camera, the subject was centered in the frame. In the outdoor portrait on the right (above), the subject was looking toward one side, making it desirable to leave space in the viewing direction.

A single subject in front of a plain background (bottom left) is most effectively composed in the center in any format. This also applies to advertising photographs of a single product, unless the art director's layout specifies another composition.

Left: Close-ups of flowers are best photographed like people. Center the flower if it is photographed from the front; compose it toward one edge of the frame if photographing from the side.

Below: If a subject seems to be moving (as in this funeral procession in Malaysia), allow extra space in the direction of the movement.

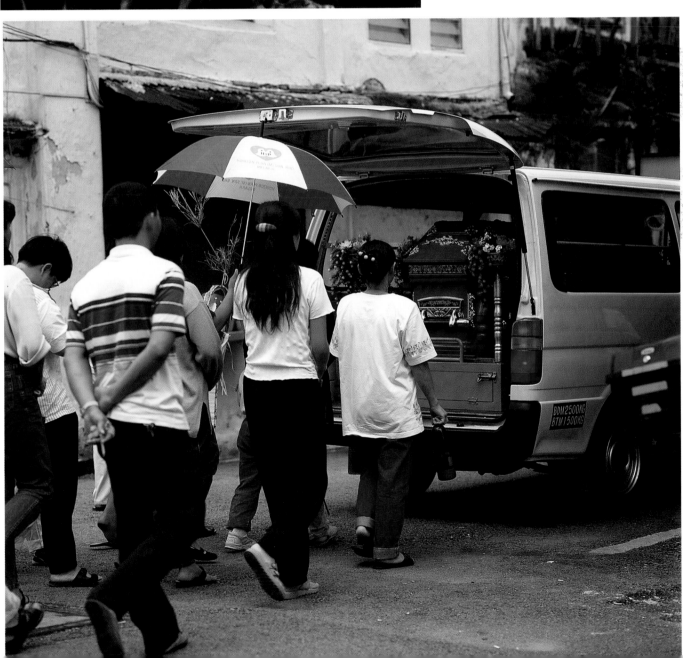

a portrait with the person looking directly into the camera.

This central subject placement applies in any image format, horizontal, vertical, or square. I suggest, however, that you give special consideration to the square for such a composition. The square is often more effective for such a composition, as it surrounds the main subject by a more or less equal space on all four sides. This arrangement may make a more effective presentation than a rectangular image that has more empty background space on two sides than the other two. The square format somewhat emphasizes the central subject placement and may also help to eliminate distracting elements in the background.

However, if the person in a portrait is not looking straight into the camera but towards one side, you may want to get

The house in the background, the main subject, was composed in the center because it is evenly balanced by the two boats in the foreground.

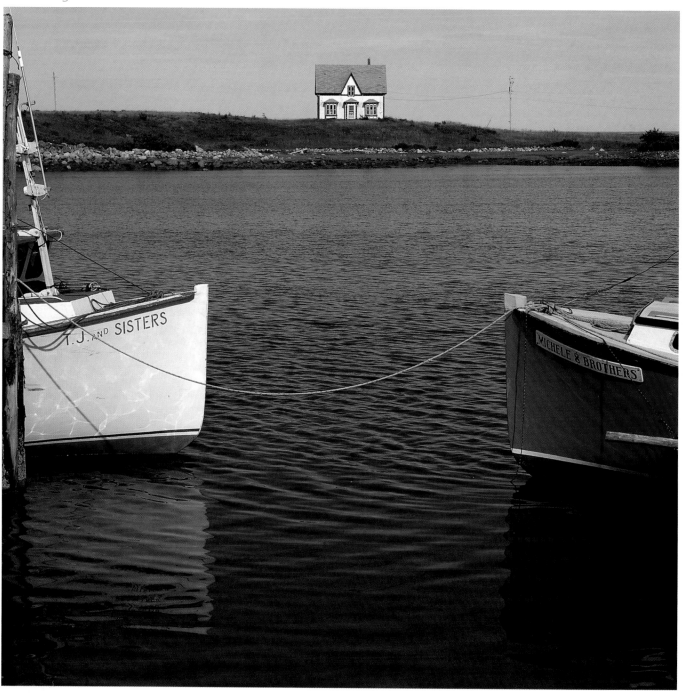

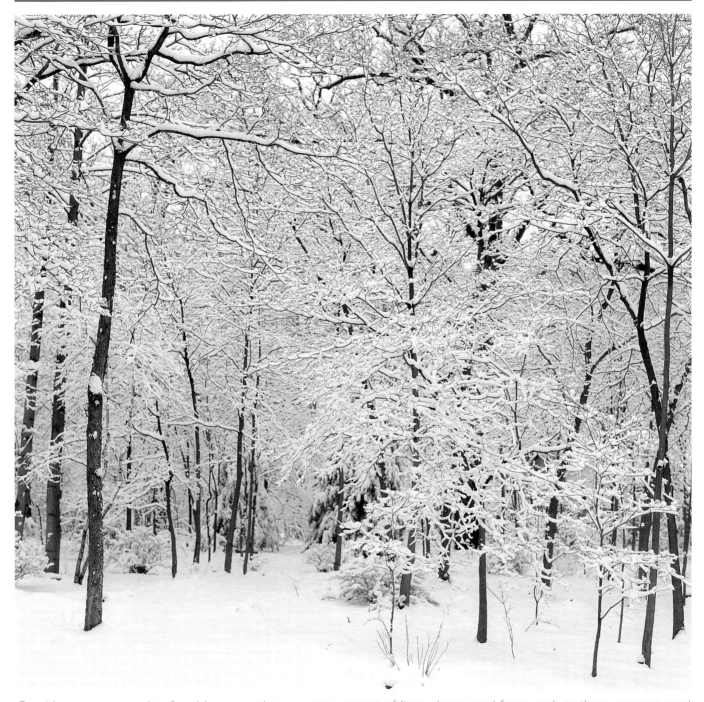

Good images can consist of nothing more than an arrangement of lines, shapes and forms such as these snow-covered trees.

away from the central subject placement by situating the head of the subject more towards one side and leaving somewhat more space in the direction of viewing. The same applies to the image of the vase with flowers if all the flowers in the vase bend to one side.

You also want to stay away from central subject placement with subjects that seem to be moving, such as a swan swimming in a pond, a sailboat on a lake, a bird flying through the sky, or a child running. It is best to give the subject an area in the frame to move toward

(leave more space in the apparent direction of movement).

■ **Placement of Main Subject**

While central placement of a single subject is frequently best, the visual effect is somewhat static. A more dynamic effect is achieved by placing

the main subject towards one side or towards the top or bottom. The most effective position depends, of course, on the other image forming elements, but you will seldom go wrong by considering again the 1/3 positions. Place a subject that is elongated vertically (such as a tree, a flagpole or the mast of a sailboat) approximately 1/3 from the left or right margin. Place main subjects that are elongated horizontally (such as a fence, a stream or a horizontal rock formation) approximately 1/3 from the top or bottom.

With main subjects that are not dominantly horizontal or vertical but are of any other type and shape (an old barn or a church in the distance surrounded by fields and trees, a boulder surrounded by ferns), you can hardly go wrong by placing such subjects in what I call the four perfect subject placement points. These points are approximately where the

Repetition in the windows, tiles, chimneys and rooflines of the city of Prague is the main attraction in this image.

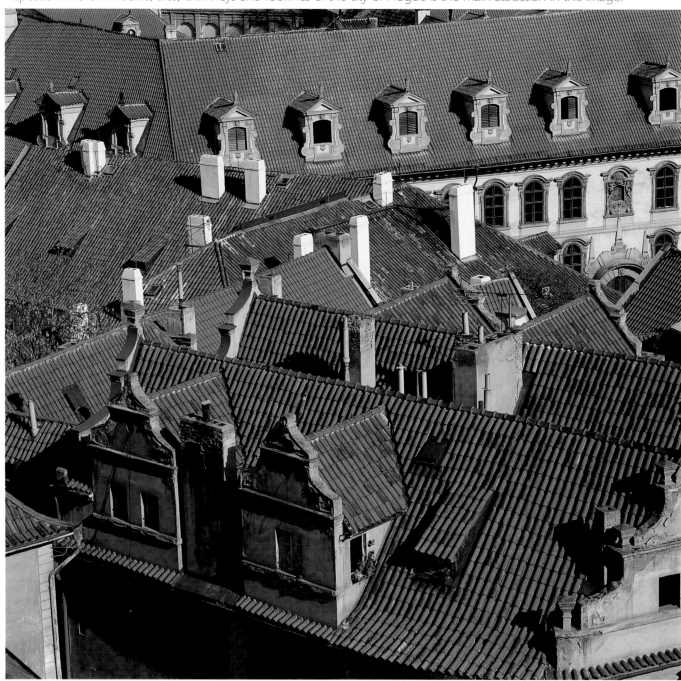

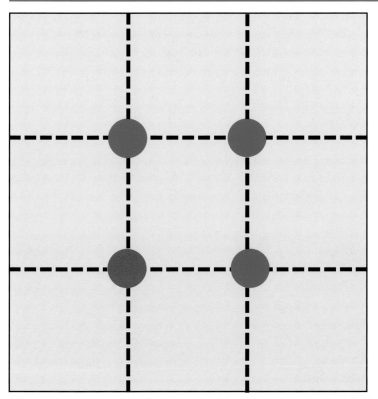
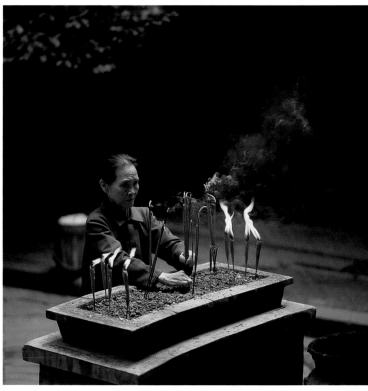

In any format, we have four good subject placement points (left). These are 1/3 from the top and bottom, and 1/3 from the left and right. The image on the right of a woman in a temple in China is an example of good subject placement.

horizontal lines 1/3 from top or bottom meet with the vertical lines 1/3 from the left or right. We thus end up with four meeting points that are excellent places for positioning the main subject. This suggested subject placement results in a pleasing image in all picture formats, square, horizontal or vertical in any aspect ratio. It even applies to panoramic images. There is nothing new to learn when you switch from one format to another, or if you work with different format cameras.

The suggested 1/3 subject placement works most successfully in combination with other image forming elements that give the image the necessary balance. The position of these additional elements then determines which one of the four 1/3 subject placement points must be considered for the placement of the main subject.

> *"...an uneven number of elements is always better..."*

■ Number of Elements

Designers and decorators will say that an uneven number of elements is always better than an even number. A landscape designer's blueprint will undoubtedly show three birch trees, not two in front of the house. Uneven numbers always work well in our photographic compositions. You can hardly go wrong with one main subject properly placed within the image area. With three elements, they can all be main subjects. More likely, they will consist of one main subject and two secondary subjects. The viewer's eye is then attracted first by the main subject, travels from there to the second and third and back to the main element. Three elements are generally easy to compose and arrange in any format. Two elements of equal importance seldom work well. They fight with each other, make the eye jump from one to the other, not knowing where and when to stop. Two subjects work if one is clearly recognized as the main element, and the other as a secondary one.

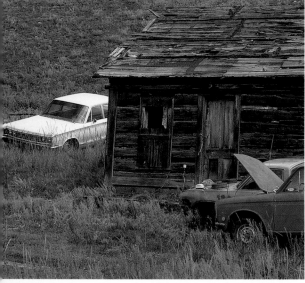

With two subjects (left), the viewer does not know what to look at – the white car at the side of the building, or the red and blue ones in front of it. Concentrating on the two cars in front (below) provides a better visual result.

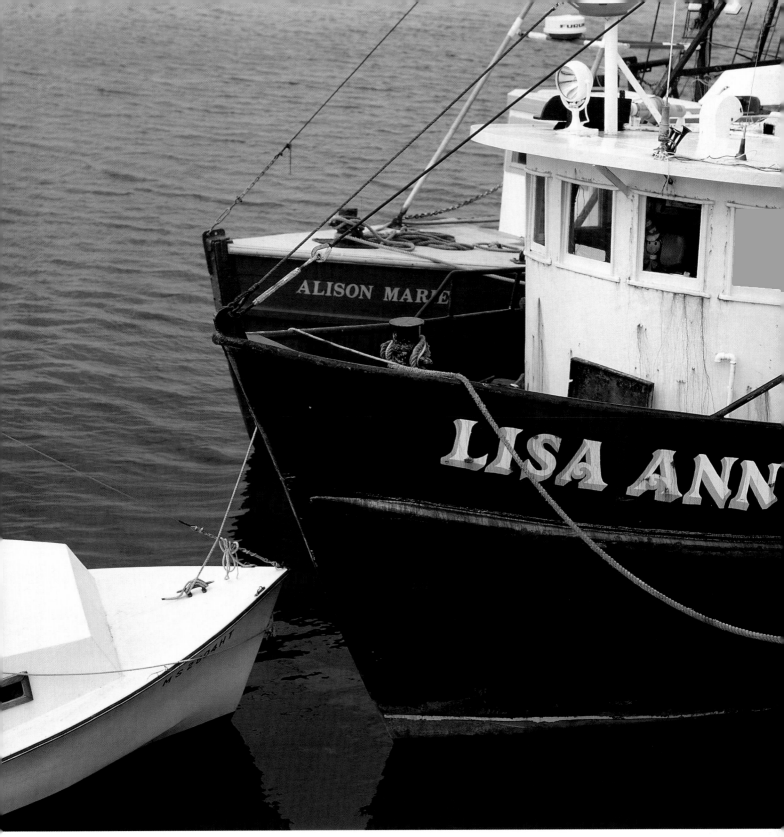

In some instances, two subjects can work well. Here, they are the same shape and color with the white on the small boat repeated by the white on the Lisa Ann. This repetition of shape and color conveys the reason why the two of them are in the same composition.

This scene taken in St. Petersburg, Russia, seems to be missing a main subject.

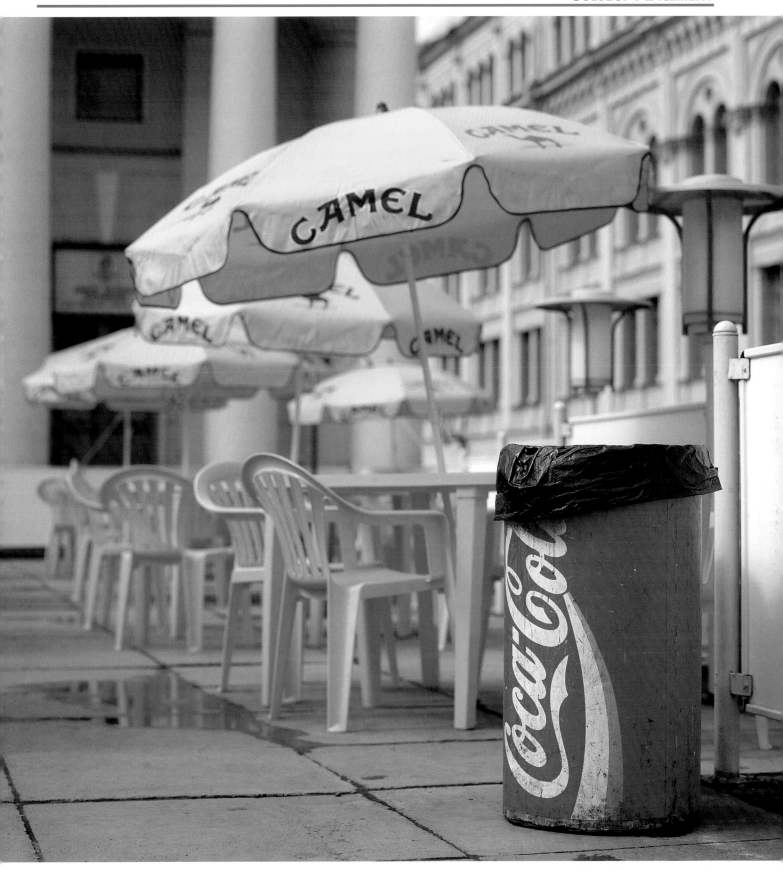

Taken from a slightly different angle, the bright red trash can becomes a main subject because of its different shape and color.

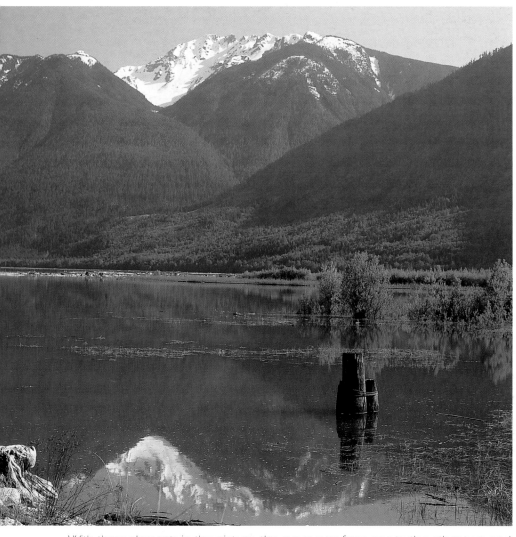

group; if the family consists of four, we have to work with four elements (unless we can add a pet). We must try to do the best with four elements. Avoid arranging them as two and two, (for example, two standing and two sitting). Instead, make it three and one (three standing and one sitting, or vice versa). Also look for the possibility of composing and photographing the group in a location where you can include an additional element, perhaps a garden ornament, the white trunk of a birch, a pillar or flower box on a home or a railing. Such a subject included as part of the composition can then serve as the fifth element in a group of four.

With three elements in the picture, the eye moves from one to the other two and back to the first. Here, the viewer's eyes move from the snowy peak of the mountain top, to the reflection of the snow in the water, to the dark stump, and then back to the mountain top.

■ Group Pictures

The issue of the number of elements also comes up when photographing group pictures. In this case, it is the number of people in the group that makes up the number of elements. A group of three or five always works well. A full length shot of a group of two tends to be quite static and boring visually. Such pictures are accepted when it involves a bride and groom, probably because we do not expect to see anybody else.

Head and shoulder portraits of two people give us greater opportunities for composing a more exciting image.

> "A group of three or five always works well."

We usually cannot change the number of people in the

7
IMAGE BALANCE

◼ Balance of Subjects

When the main subject is placed about 1/3 from top or bottom and 1/3 from left or right, the other side of the image area needs elements that provide the necessary balance to the image. These balancing elements are required perhaps for no other purpose than to emphasize the reason why the main subject is placed to one side rather than in the center.

Balancing elements can be of any type and shape. The balancing element may be nothing more than the line of a road or stream leading the eye towards the main subject. The balancing elements can be other subjects which are the same (or similar) in shape and type to the main subject, or they can be completely different. Regardless, they must be in some way related to the main subject.

The balancing elements must also be placed effectively within the frame to really look like a balance to the main subject. Other 1/3 placement points within the picture are usually good choices.

"Balancing elements can be of any type and shape."

In a rectangular or panoramic picture, you frequently need to balance only the other side of the image (the left side, if the main subject is on the right, or the top if the main subject is at the bottom). Many images, however, can be further improved visually by balancing both the other side as well as the top or bottom of the image. For example, an old barn on the upper right could be effectively balanced with a portion of an old fence at the bottom left. The fence is now a horizontally and vertically balancing element.

Balancing the other side as well as top or bottom must be seriously considered in the square format with its harmonious vertical and horizontal dimension. The square calls for an image balance in both directions. If the main subject is in the lower right, place the balancing element in the upper left.

Whatever the balancing elements are, and wherever they are placed, they must be of lesser importance than the main subject – smaller, less interesting, less noticeable. With a balancing element that is of equal importance, you actually have two main subjects in the picture. This is seldom a good compositional arrangement. It makes the eye jump constantly from one subject to the other, never knowing which one is more important or what the image is supposed to show. Keep the secondary subject secondary. Let me emphasize again, however, that there can still be good reasons for disregarding this rule. Two subjects can be effectively used in an

The shape, size color and pattern of the tree makes a practically perfect balance for the building.

image where you want to emphasize the sameness or similarity of two object (two identical skyscrapers, two identical doorways or two identical flower boxes). Having two or more main subjects of practically identical importance in a picture is also typical in advertising illustrations. The image may include two or more perfume bottles, fashion outfits or practically any other products. In such a picture, you expect or want the viewer to jump from one to the other.

■ Subject Sharpness

When considering the balancing elements, it also worthwhile to give consideration to the the degree of sharpness with which the balancing element will be recorded in the camera.

Since the main subject is likely to be sharp, balancing subjects usually provide the best balance when they are also sharp or reasonably sharp. A completely blurred subject is not likely to provide effective balance for a sharp main subject. The degree of sharpness in the various subjects is determined by the lens aperture. When working with a single lens reflex (SLR) camera, use the manual aperture stop down control to evaluate the degree of sharpness or unsharpness in the various subjects.

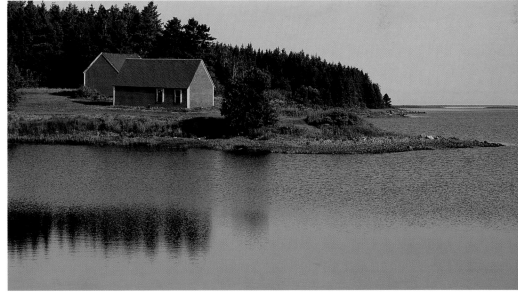

The image is unbalanced in the square format as all the elements (the red building and the green grass) are on the left. The image can be better balanced by changing to a horizontal format and eliminating the grass.

8

THE IMPORTANCE OF COLOR

■ Balance of Colors

Since balancing elements are to be secondary, they must not attract special attention or be distracting. The choice is made easier if you keep in mind that a viewer's eye has a tendency to be attracted by the brightest areas in an image. Consequently, avoid brightly colored subjects or areas in the balancing elements. A brightly colored area attracts even more attention if it is next to a dark area – white next to black will attract the eye almost regardless of how small the areas might be.

In a color image, you must try to achieve not only a balance of elements but also a balance of colors. For example, in an image with a good arrangement of red apples on the left and green apples on the right, you may have a good composition of shapes but not a good balance of colors, since all the reds are on the left and all the greens are on the right. To achieve a balance of colors, you must repeat the red on the right, perhaps by placing one red apple among the green apples on the right side.

Most images call for at least one of the balancing subjects to be of the same or similar color as the main subject. For example, in a harbor view with a bright red boat on the bottom right side, another smaller boat in a deep orange shade on the top left side will form a good balance between top and bottom, left and right.

> *"... color harmony needs to be considered."*

Since the choice of balancing elements is almost unlimited, you should seldom have a problem composing the subject or scene in an effective fashion in either a black and white or color image. What it will require, however, is looking at the subject or scene from different angles – high angles, low angles, moving a little to the left or to the right, or viewing the scene through different lenses and/or from different distances. A different angle or a smaller or larger area of coverage can usually bring in a balancing element, especially in the background of an image. If balancing elements cannot be found, changing the shape of the image may solve the problem. For example, if an element for balancing the top of a square image cannot be found, consider composing the image as a horizontal.

■ Color Harmony

Wherever colors are used (in photography, art, decoration or attire), color harmony needs to be considered. Color harmony refers to the fact that certain colors go with each other better than others. Some colors enhance certain other colors, harmonize with certain colors,

The mailbox in the photograph on the right repeats the pattern and color of the roofs on the buildings and contributes the necessary balance lacking in the photo on the left.

or look right next to certain other colors, while other color combinations may distract.

I feel that most people, unless color blind, have a pretty good feeling of color harmony because it is not solely related to photography and art. Color harmony is something that needs to be considered in our daily life. We try to wear a jacket that harmonizes with the color of our slacks. We try to select a tie that harmonizes with the jacket and shirt. We need to consider color harmony when decorating or painting a house or room.

A paint store is actually a good place to learn something about color harmony. Paint manufacturers have literature with good examples of color combinations on exteriors of houses. These illustrations show what colors in shutters and trim look good against the color of the walls. They also have loads of sample books of wallpapers. Most papers have patterns of colors that harmonize with each other. The papers were created by people with an understanding of color.

> "The different colors also convey specific moods."

Colors that go well with each other may be harmonious, meaning that they are of similar shades, such as brown and beige. In such a combination, the colors strengthen each other. The various colors can also be complementary, such as blue and yellow or red and green. Such colors create a contrast, fighting each other – and even killing each other.

The different colors also convey specific moods. The blues are considered cool colors and convey that mood in the picture. Cool colors have a tendency to recede. The reds and yellows are warm colors, giving the viewer a feeling of warmth and pleasure and having a tendency to motivate or pull forward. Green and grey are passive colors that are easy on the eye and create a restful feeling. White is the color of joy

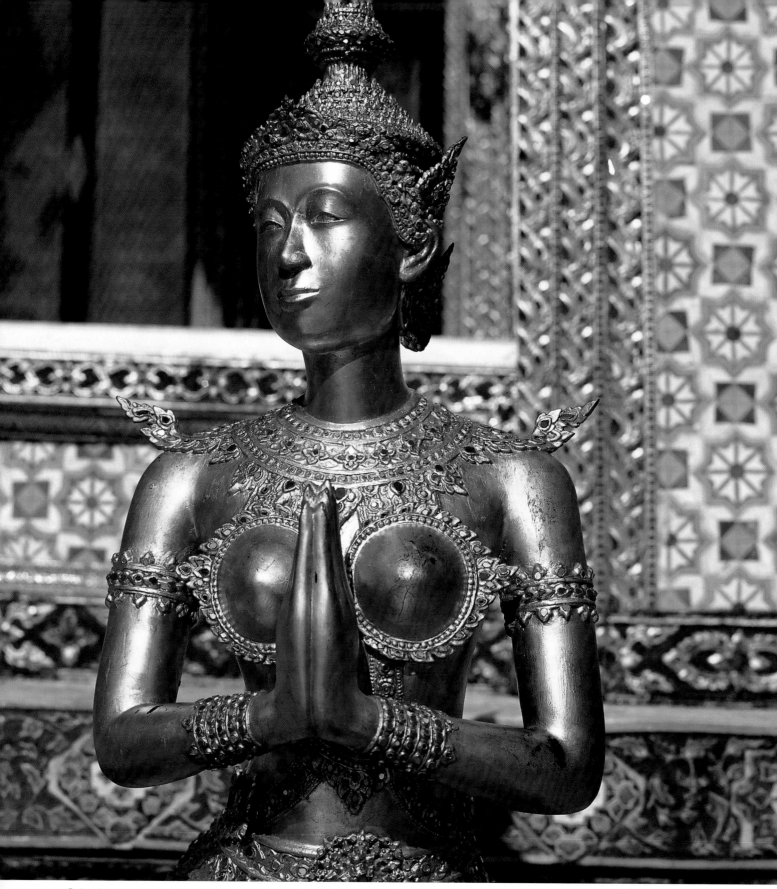

Color balance can be achieved even by minor elements, such as the blue and gold background pattern repeated on both sides of this figure on the palace grounds at Bangkok. Opposite, the buoys in the foreground repeat colors from the boats and houses.

and innocence, a good reason why white or light colors should be selected as a background for portraits of children.

Black is the color of mourning and death, obviously a poor choice for a background color in child pictures but wonderful for portraits of older people.

Colors are also more or less intense and can appear more saturated or be more pastel. The brightness and saturation is determined by the color of the subject itself as well as by the lighting. Sunlight provides more brilliance, saturation and contrast. Red can look brilliant in sunlight but more pastel in the soft light of an overcast or foggy day. The saturation can be some-

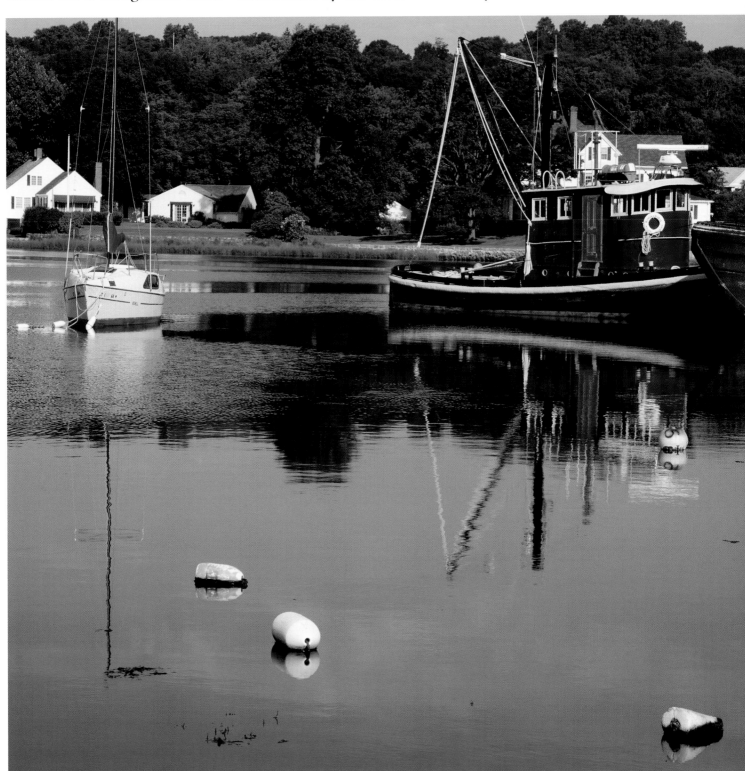

what changed by exposure, but only to a very small degree. A slight overexposure creates a more pastel look, whereas slight underexposure creates somewhat more saturation. This change is possible only to a small degree before the image looks over or underexposed.

> "A slight overexposure creates a more pastel look..."

Considering the color of subjects and color harmony is also valuable when considering subject balance in color photography.

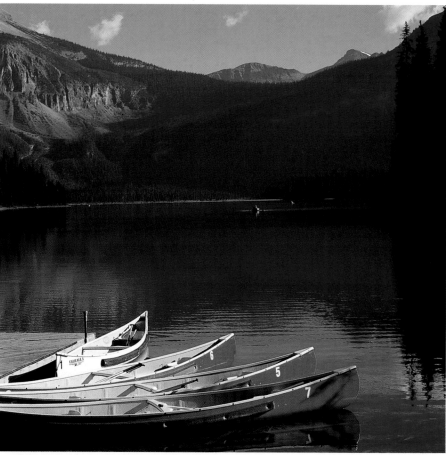

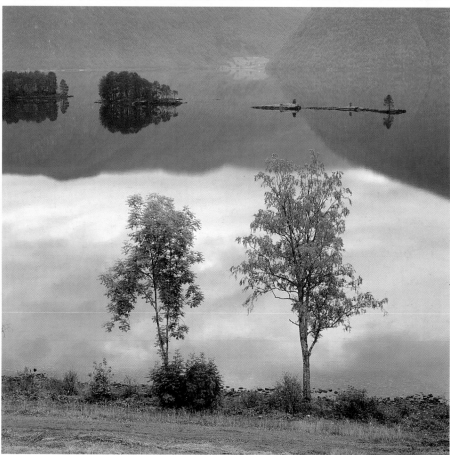

Color harmony was achieved by using colors of similar shades, such as green and blue in the bottom image, or complimentary, such as red and blue in the top image.

An overcast day provided subdued, pastel colors and a restful feeling in the top image – especially when compared to the bottom image with its brilliant colors and color saturation created in bright sunlight.

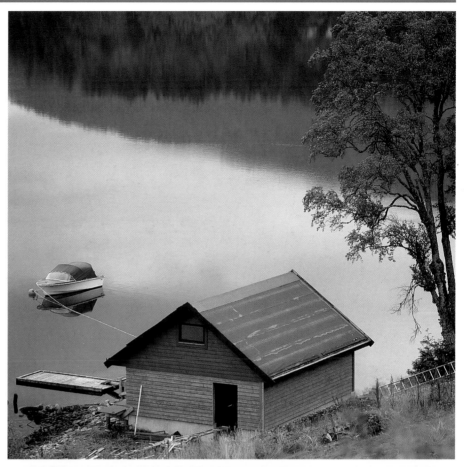

9

BACKGROUND COLOR AND BRIGHTNESS

Backgrounds are an important part of many of our images. Therefore, the type, color and brightness must be an important consideration.

■ In the Studio

In the studio, we usually have full freedom and choice since we "create" the background. We can select the type and color of the background and even light it in a specific way to create the desired effect. We can truly create whatever is most effective.

■ On Location

On location, the possibilities are somewhat more limited, but certainly not out of our control. In outdoor or location portraiture, as well as product or still life photography where backgrounds are an important part of the final image, the background is determined first of all by the location that we select for the shoot and secondly by the camera position in relation to the sub-ject. The camera position determines what is in the background, and a change of position can often bring a darker or lighter area (or a different colored area) into the background.

> "Backgrounds are an important part of many of our images..."

By changing the focal length of the lens, you can also change the size of the background area. These choices are somewhat more limited in a full length portrait than they are in a head and shoulder portrait or in a close-up of a small product or any other small subject.

■ Bright Backgrounds

Since a viewer's eye is generally attracted to bright areas, bright backgrounds cannot be used indiscriminately. They can easily distract from the main subject – just as a white mat or border distracts from a print. This is especially the case with a projected transparency. Bright white areas on a screen can be very disturbing. White backgrounds can, however, also serve a purpose: they can form a strong contrast to the main subject, and by doing so attract the viewer's or the reader's eye. This is a reason why they are common in fashion pictures and in some product advertising illustrations.

■ Creating Mood

Background colors can help creating a certain mood. White and light colored backgrounds convey a feeling of happiness. That is why I like them in studio portraits of children and young people and in wedding portraits. The light colors convey a positive mood associated with childhood or young people's lives. Dark backgrounds convey the opposite moods of mystery, sadness, tragedy and death, and in my mind should be limited to

White or light-colored backgrounds are most effective as backgrounds for children and young people.

portraits of older people. This suggestion for background color applies not only to studio portraits but to outdoor portraits and wedding pictures as well. It is worthwhile to carefully consider the background and its color in location portraits.

Your choices are sometimes limited, but different backgrounds can be present even in one and the same location. You might find both a bright sunny background suitable for young people or the wedding party, as well as a darker, shaded area for the older folks simply by changing the camera angle and/or perhaps the lens.

> "Make a habit of watching... the background."

Make a habit of watching not only the subject but also the background. Check its brightness and color and also check what the background subjects actually are. The background must not only enhance the image but must also be appropriate for the people in the picture, the way they are dressed, and the mood that you want to convey. For example, people who are informally dressed belong in an informal setting, while a formal party belongs in a formal setting.

■ Background Sharpness

Last but not least, always check the degree of sharpness or unsharpness in the background at the decided lens aperture. If unsatisfactory, create more or less blur by opening or closing the aperture, or if that is not successful, select a background area that is closer or further away from the main subject.

Dark backgrounds, as above, can enhance portraits of older people shot either on location or in the studio.

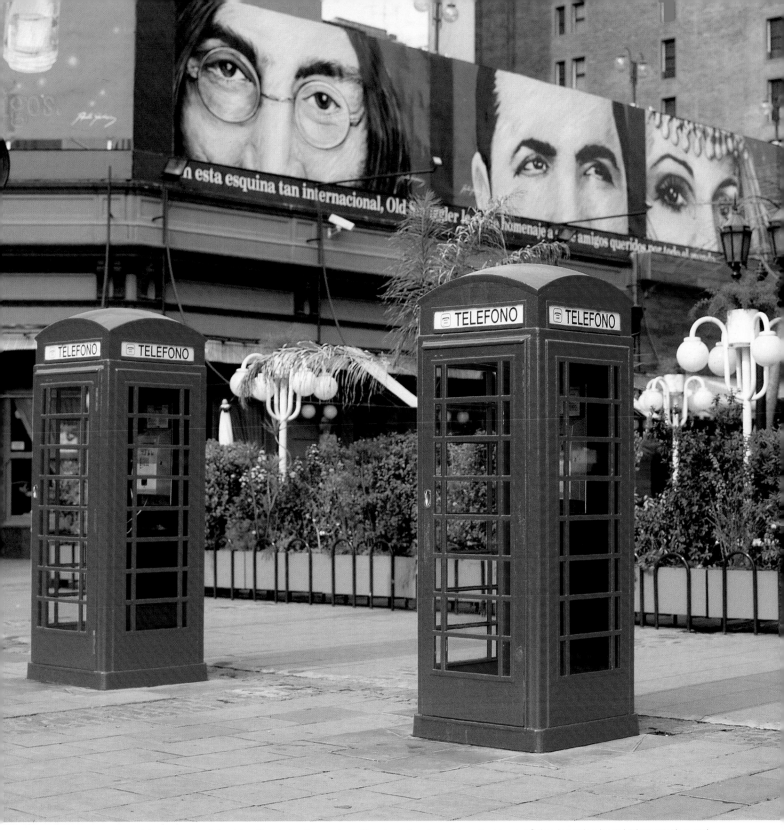

I was attracted to this scene not just by the telephone booths, but the bright red colors of the booths in relation to the colors and subjects on the advertising boards in the background.

10

DISTRACTING ELEMENTS

Good image composition helps in creating a visual impact that is beautiful, interesting and enjoyable to view – hopefully more than once. The image can accomplish this only if it is also free from elements that distract from the enjoyment of the image or distract from whatever message the image is supposed to convey.

Watch carefully for distracting elements when viewing the subject or scene in the viewfinder. You may have problems eliminating them afterwards. In a motion picture or video, possibilities for eliminating such elements afterwards do not exist for the ordinary person. In a motion picture or video, keep in mind that anything that is moving also attracts attention. Let's look at the distracting elements that often ruin an otherwise good photographic image.

■ Technical Faults

A photographic image can be enjoyed only if it is free from obvious technical faults – things that happened or were overlooked when the picture was taken. A quality photographic image requires good exposure and sharpness at least somewhere in the image.

"Watch carefully for distracting elements..."

An image that is blurred everywhere, whether it happened accidentally (through camera motion or lack of focusing) or purposely (by using soft focus filters or lenses), is usually not a good photographic image. We always expect to see something sharp somewhere in the image because we never see everything blurred with our eyes. The sharp area may be nothing more than a sharpness in the eye of a portrait or a sharpness in a reflected high-

light on a body of water, but something must be sharp. This also applies when using soft focus filters or soft focus lenses. Select and work with lenses or filters that maintain sharpness. Some do, some do not.

Technical perfection includes not only the obvious requirements like exposure and sharpness but many minor distractions. Let me mention a few that often show up in photographs.

- Horizontal or vertical lines that should be horizontal or vertical but are not.
- Reflections from a flash on a shiny background.
- A photographer's reflection or shadow appearing in the picture.
- An insufficient range of sharpness (depth of field).
- Darkened corners caused by the use of an improper lens shade or a filter that is too small in diameter (sometimes by a poor lens, especially a wide angle).

- Fill flash that made the subject too bright or too dark, or red pupils in people's eyes caused by the flash being too close to the lens when the picture was made.

- Blue skies that are unevenly blue from side to side from using a polarizing filter on a wide angle lens.

Photographers are undoubtedly more aware of such technical faults than non-photographers, but they do not belong in a good image regardless of who sees your work.

■ Bright Areas

In a color or black and white image, a viewer's eye is always attracted by bright areas, almost regardless of how large they are in the picture or whether they are in the main subject or in the background. The bright area may be nothing more than a shiny reflection on a motorcycle or a distant window. A slight change in the camera angle may make a drastic improvement in such cases. A small bright area close to the main subject may not be disastrous and may even help attract the eye to the main subject. With such an area in another part of the image, you probably have a problem. It will distract.

In the image above, the eye is attracted by the white horse on the left. This, therefore, becomes the main subject of the image. In the bottom image, the small boat is an element because of its brightness within a dark area. This composition works because the boat forms a balance to the light colored building on the left.

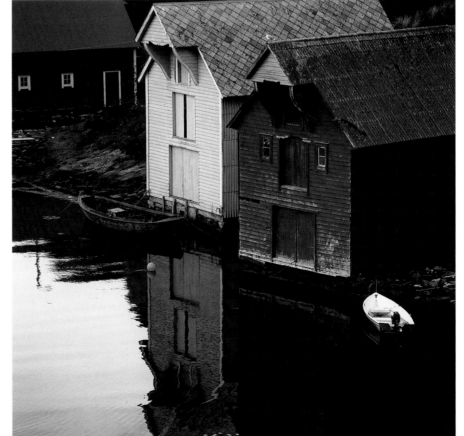

The main attraction in the square photo below is not the pair of seagulls, but the pair of dark spots in the water. They attract the eye because they are next to a bright area, and also because they are out of focus. The same applies to the dark area on the upper left which also crosses the border. Both can be eliminated by changing the image shape (as above).

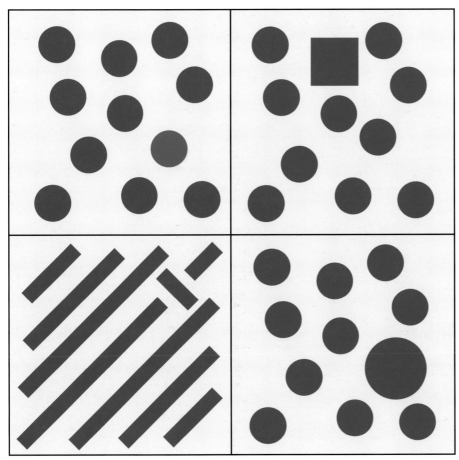

The eye is always attracted to anything in the frame that is different in size, shape, color or orientation.

In a color image, the distracting area can be of the same color but a brighter shade than the main subject, or of a brighter color (yellow for example, when the main subject is brown.) It is difficult to point out specifically what distracts and what does not, so I can only suggest that you evaluate the image carefully, watch what attracts the eye and look at the entire image from top to bottom and side to side. Preferably do so before you take the picture. It may be difficult to eliminate distracting elements afterwards, especially in a color transparency.

■ Other Distracting Elements

The viewer's eye is attracted by any element within the picture that has a different shape, size, or color – or that goes in a different direction. Such elements attract the eye, especially if they are the only ones of that type, size, or color, or the only one going in that particular direction. Let me illustrate this point with some examples.

A boat that is positioned vertically within a hundred boats that are horizontal creates attention because it is the only one going in that direction. The small trunk of a broken tree that lays diagonally in the midst of gigantic vertical tree trunks attracts attention since it is the only element going diagonally. In a flower bed with a large number of red tulips, and one yellow tulip, our eye is likely going to the yellow tulip first. In a picture of a tree-lined road with a stop sign at the end, the sign is likely to attract attention because it is the only element that is red and of a different shape. The same applies to a winter scene with a red traffic light, or in a still life of three red and five green apples and one yellow banana. The banana attracts attention due to its different shape and color. In an autumn market display of perhaps five large pumpkins and one small one, the viewer will most likely see the small one first, even though it is a minor element in the overall picture.

Two things can be learned from these observations.

First, since a subject of a different size, shape, color or orientation attracts attention, such a "one of a kind" subject makes an ideal main subject. It attracts the viewer's eye to that part of the image. Be sure to place these subjects where they help the composition most. You can only fail if there is something else in the picture that attracts even more attention.

Second, beware of having such "one of a kind" subjects or areas *in addition* to the main subject. They may and probably will attract the eye more than the main subject does. Try to eliminate or reduce them

The dark tree trunk is distracting because it is the only dark area in the picture. A slight change in camera angle could have eliminated this problem.

image, especially if they are of a bright color. Such elements need not necessarily be large or dominant, as it is not so much the subject itself that creates the attention but the fact that it crosses the border and goes out of the picture frame. A small white house in the distance may be a perfectly natural part of the composition when we see the entire house, but the same house can be awfully distracting when cut in half by the border.

> "Such elements... make the eye move out of the picture..."

The "border crossing element" may be just a line, especially one of a light shade or color. Our eyes tend to follow the line, stop at the point where the line crosses the border and stay there. The crossing point becomes a center of attraction. If the border crossing area is larger and more dominant (a figure partially in and out of the frame, a cow in a field cut in half, a chimney on top of a house cut off) the problem is enhanced. Watch for any subjects along the border that are partially cut off, regardless how small they might be.

You probably have seen fashion or documentary pictures with a person's head partially cut off. This is usually not a mistake in a professional pic-

before you take the picture. This statement does not mean that secondary elements can never be of a different shape, size, color or go in a different direction. They can, but they must not be too dominant. For example, the lines of a mountain range in the distance can go horizontally and/or diagonally behind a line of vertical trees. Or, a line leading to the vertical main subject can be diagonal.

While the above observations should be considered when composing the image in the camera, they are perhaps most helpful when evaluating the images afterwards. They may make you more aware of

why some images are more successful than others and why some images attract and hold attention while others seem to lack this necessary ingredient.

■ Border Cutting Elements

When evaluating a scene in the viewfinder, watch especially for any type of distracting element that is close to the border of the image. Such elements may not only distract but also have a tendency to make the eye move out of the picture – the last thing that we want to happen.

Even worse are attention creating elements that actually cut into the border of the

ture. It is done purposely for visual impact, to force the viewer to actually look to the area of the "border cutting point." The reason may be to make the subject's eyes a focal point, as the eyes are right below the cut off area. To put it differently, the cut off area "forces" the viewer to look into the subject's eyes, and makes the expression in the eyes a strong visual element. Such a composition can also work in a fashion picture for selling eyeglasses. The eyeglasses become a focal point, as they are right below the cut off area. Such a composition, on the other hand, may accomplish the wrong effect if the picture is to sell a garment, especially the pair of slacks or the pantyhose that the model is wearing.

"A border crossing point becomes distracting..."

A border crossing point becomes distracting when an element goes out of the picture and also when such an element from the outside comes into the picture – when the image includes a branch from a tree that is outside the picture area, or when you can see an arm that belongs to someone not included in the picture. Such elements must be eliminated.

This observation does not mean that we can never cut into a line or a subject. A main subject must usually be shown in its entirety. A church steeple cut on top seldom looks right. An autumn colored tree as a main subject must be in the picture from top to bottom. In many other pictures, trees are secondary subjects and can be cut at the top or on the sides. As a rule, however, a tree trunk must go down to the ground so the tree does not appear to be floating in the air.

The two figures in the background are distracting because they cut into the border and one of them is the brightest part of the image. Changing the picture shape eliminates the troublesome elements and isolates the viewer's eye on the main subject.

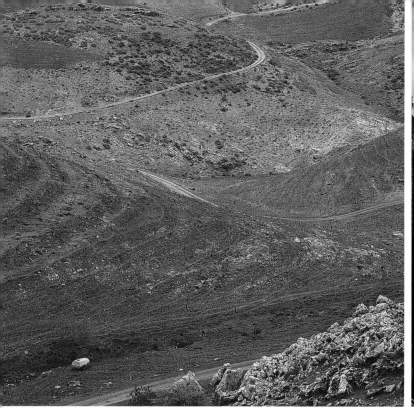

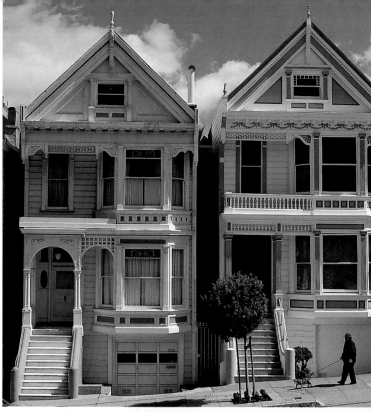

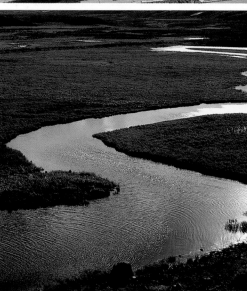

The element that attracts the eye because of its difference can be quite small, such as the yellow vehicle in the photo on the left (above), or the pedestrian in the photo on the right (above). A subject that goes in a different direction (such as the curved tree trunk amidst the straight, vertical ones in the image on the left) also attracts the eye and can make or ruin a picture. Above, the picture of a beautifully curved stream is ruined because the eye is attracted to the point where the brightest area of the stream cuts into the border of the image.

■ Avoiding Compositional Mistakes

How can we avoid such compositional mistakes that involve border crossing elements? When you frame the image in the viewfinder, don't just look in the center of the image. If time permits, also move the eye to all four sides of the frame and watch for anything that might be distracting, such as subjects that are partially cut off or should not be in the picture at all. A slight change in camera angle or changing to a longer focal length lens can frequently eliminate such elements, espe-cially when they are in the background.

You are more likely to per-form such a critical image eval-uation with a tripod mounted camera, which is perhaps the best or only reason for using a tripod for scenics.

You may also be more criti-cal when you compose on the focusing screen of a single lens reflex camera than the optical viewfinder of a rangefinder or point and shoot type – and per-haps even more so with the larger focusing screen of a medium format camera.

Whatever format or camera type you use, make a habit of careful and complete image evaluation. It will eliminate a lot of problems that may be diffi-cult or impossible to eliminate afterwards.

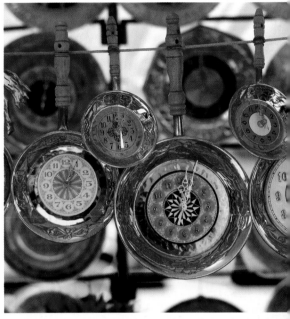

This square image taken in Mexico can be improved by eliminating the border crossing elements at the top and bottom, and also eliminating the horizontal rope (otherwise the only horizontal element in the image) from the top of the frame.

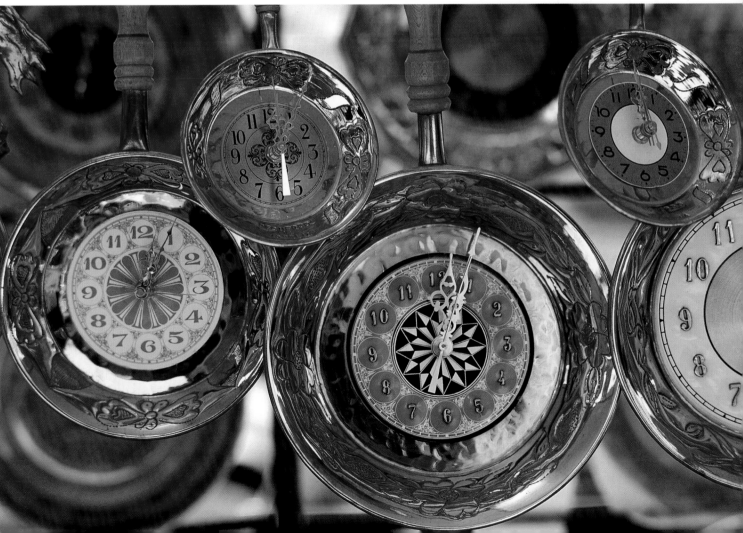

11

IMPROVING IMAGES AFTER THEY ARE TAKEN

◾ Cropping

While the possibilities of improving compositional faults recorded on the film are limited, they do exist. One that always must be considered (in any image format) is changing the shape of the image. When the image includes distracting elements close to the edges or cutting into the border, the first consideration should be to change the image shape when making the print or by masking the transparency.

Going a step further, you could also use this approach to produce "close-ups" by cropping – using only part of the original negative or transparency. Consider this only as an emergency tactic, as it will produce a subsequent loss of quality. Close-up possibilities must be investigated when taking the picture.

◾ Dodging and Burning

A second possibility that must be considered comes in black and white printing. In a black and white print, bright disturbing areas can be made darker and less distracting in the darkroom. You can also make dark areas brighter to show more details.

> "...change the image shape when making the print..."

In most black and white prints, the viewer expects to see some detail in the lightest as well as the darkest areas, if only because we see these details with our eyes. Keep this in mind when you make the prints.

◾ Electronic Retouching

In a color image, the possibilities for image improvement are reduced to retouching, manually or electronically, and electronic image manipulation. While I do not encourage changing photographic images electronically, combining different images electronically or other major image manipulations, the new possibilities offered in the digital field should be kept in mind by every serious photographer, even if considered only for occasional minor retouching or image improvement.

A picture that I took in Malaysia included a colorful swinging doorway with an even more colorful traffic sign right next to it. Regardless of how I tried, I could not find a way of making a good arrangement of the lines and colors without also including a not so attractive electrical switchbox on the wall. It was easy to remove this box digitally using the Photoshop® software. Naturally, a purist might say that the switchbox is part of the scene and should have been left there. I agree, but the box bothered me and reduced the enjoyment from the image. At present at least, I limit my electronic

manipulation to such types of occasional minor retouching. I continue to feel that I want to create my final image in the camera, not afterwards.

◾ Darkening Corners

A popular approach in professional studio and location portraiture is the darkening of the sides or corners of the image. The purpose is primarily to draw attention to the face of the person, but a secondary purpose might perhaps be to make it look like a professionally created image rather than an amateur snapshot. The darkening can be done in printing or in the camera when taking the picture; this is usually referred to as vignetting.

Darkening the sides and corners will emphasize the main subject and prevent the eye from moving out of the pic-ture. This approach can help make the portrait look more professional, but only when done to a certain degree. Be careful not to overdue it. Any darkening or vignetting should hardly be recognizable and should never attract undue attention. Vignetting, like anything else that is different, has a tendency to attract attention and in many professional portraits that I see, the vignetting is done so excessively that it becomes an attention-creating element and distracts from the enjoyment of the portrait. This is especially the case when vignetting is done in the camera, where not only part of the background but also part of the person is darkened. When arms or hands have a completely different tone than the face, the result looks artificial and the effect is distracting.

As to the popular comment that such vignetting gives the portrait the "painterly look" I must say that I do not remember ever having been distracted by such artificial darkening in a painted masterpiece. Artificial darkening is especially unacceptable in an outdoor portrait where the natural backgrounds must look natural.

In the studio, you can accomplish "vignetting" with lighting by setting up the studio lights to emphasize the person's face while keeping other parts somewhat in the shade. This type of "vignetting" can look natural and make the portrait more effective. You can frequently accomplish similar results outdoors with careful placement of the model in relation to the existing lighting.

The somewhat distracting switchbox in the image above was eliminated using Adobe® Photoshop® software.

12

KEEPING IMAGES SIMPLE

One Subject

Images are usually most effective with just one main subject. Often, they are visually stronger with fewer overall elements. Beginning photographers seem to have a tendency to include too much in a picture, perhaps feeling that the picture must show everything that we see with our eyes.

Not only do many of these images include too much, they often have empty space at the top, bottom, or sides. This is most often the case with images taken on point and shoot cameras with optical viewfinders. Before taking a picture, move closer and see what the subject looks like from this distance. You may find that the subject fills the frame more effectively. Filling the frame with important elements must always be the first consideration.

Less is More

Regardless of the type of camera you use, try to keep in mind the phrase "Less is More." By this I mean that most photographic images are better when they show less. Before you take the first picture, try to identify the important, essential element within the scene and build the composition around this element.

> "Images are usually most effective with one main subject."

Always make it a habit to evaluate the subject from a closer distance or through a longer focal length lens. In most cases, you will probably find that a closer view that shows less and has fewer elements is more effective.

You will probably also find that the same subject from a closer distance can be photographed in various ways, with different arrangements of lines, shapes and colors. Another arrangement could be better than the way you saw it (or photographed it) originally.

Close-ups

When I see an arrangement of fall colors, an area of bright green moss covering a rock formation or a stream flowing over rocks and stones, I usually follow up the first impression (the long shot) with six to ten closer views. Usually, the close-ups are the ones that please me most. Including less in your composition will not only produce better images, but also reduce the danger of including distracting elements.

Close-up views may be more interesting to an audience simply because many people, photographers and non-photographers alike, only see the overall views and never go close to the subject. They never see the details within the subject or the beautiful arrangements of lines, shapes and colors that exist everywhere.

Perhaps the greatest enjoyment that you can obtain from doing photography seriously is that it opens your eyes and makes you see and enjoy things that exist everywhere but to which so few of us ever pay attention. You need not travel all over the world. These beautiful and fascinating details exist everywhere – in your own backyard, on the street where you live, or in the old part of your town.

In the image on the left, the eye moves back and forth from the two water-sprays on the lower left and upper right. In the simplified image on the right, the eye stays on the one figure and is prevented from moving out of the image by the out of focus leaves.

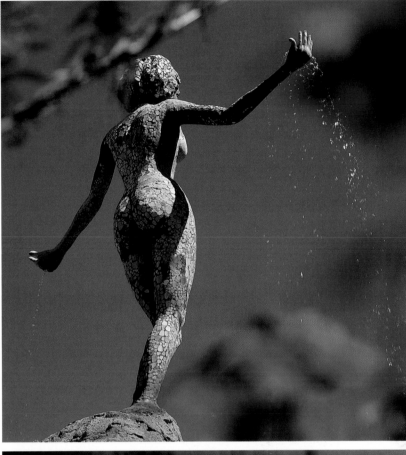

The image on the right was obtained by concentrating on one subject in the window display shown below. It should illustrate the picture possibilities that exist everywhere.

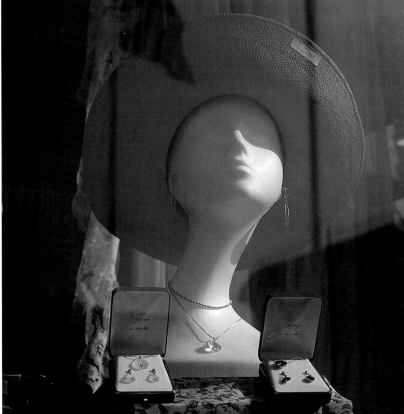

13

SHADED AREAS

◼ Technical Considerations

We generally expect to see some details in the dark and light areas of a color or black and white print. We expect to see the details because we see them with our eyes in the scene or subject, almost regardless what the actual brightness difference may be. A washed out, lighted area that does not show the details that we expect to see looks distracting (or at least unpleasant and unnatural), as does a dark area without details.

In a black and white print, you can control the density in the dark and light areas of your print, provided you have a good negative to work from. In a color print, these possibilities are limited or non-existent. It is best to make a composition that limits such areas.

◼ Color Images

A color transparency can have shaded areas with few details without being overly distracting when the transparency is projected on the screen. The light from the projection lamp going through the transparency reveals some faint details in the shadows. Knowing this, on a bright sunny day you might be tempted to increase the shadow detail by increasing exposure. Don't do it. Transparencies must be properly exposed for the lighted areas. If you try to increase details in the shade, the lighted areas become washed out and you loose color saturation.

> "We expect to see some details in the dark and light areas..."

While color negative film is the best choice for color prints, excellent prints can also be made from color transparencies. The transparency, however, may need a different exposure for this purpose. Used for viewing or projection, color transparencies look best when exposed for the lighted areas.

Transparencies exposed this way may very well have little if any details in the shade, especially if they were taken on a bright sunny day when the shaded areas were very dark. A print made from such a transparency will have even less detail in the shade, and the shaded areas may be nothing more than a patch of black.

The results on the print can possibly be improved by printing from a transparency that has more details in the shade – a transparency that has an exposure about one stop more than the one we use for projection.

You may want to keep this in mind when considering slides for projection as well as for producing prints. Shoot one image with the exposure for projection and a second one for printing.

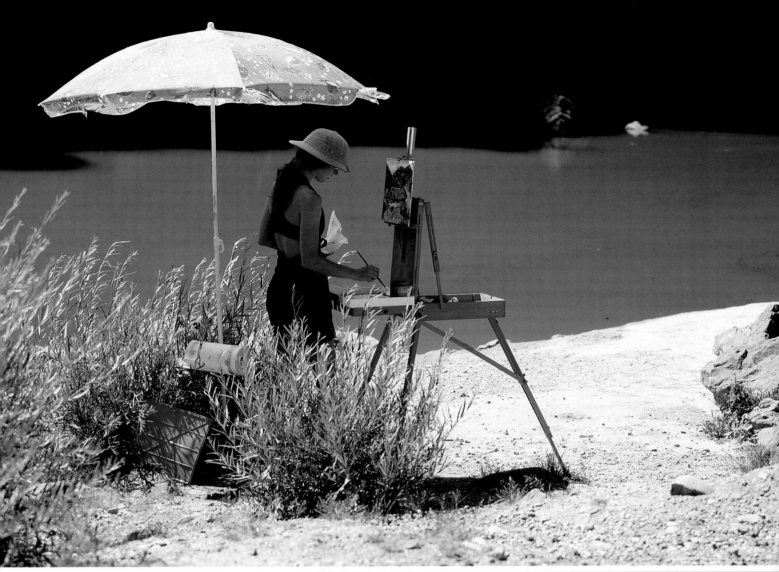

The shaded area at the top of the image on the right is too large and dominates this photo shot in a canyon near Taos. Changing the shape of the image to eliminate some of the shadow area (as above) improves the composition.

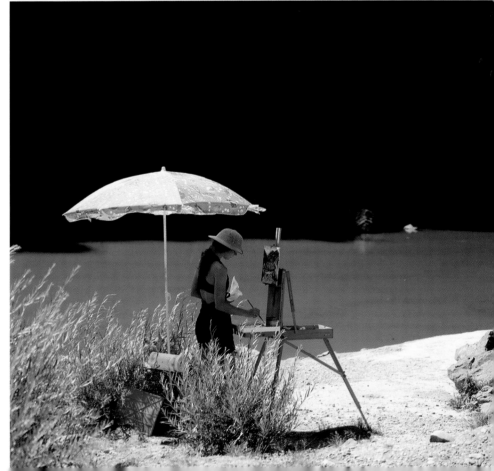

The major part of this image is nothing but a large, dark area – but it is an important part of the composition, enhancing the location and altitude of the sunlit village on top.

■ Shaded Areas as Part of the Composition

The shape or outline of a shaded area can add an interesting compositional element to a black and white or color image.

Such a case came up while travelling in the northern part of Spain. The late afternoon sun left everything in the shade except for a few houses and a church on top of a steep cliff. The dark, shaded cliff formed a beautiful diagonal line leading to the lit houses and church, which I composed on the upper left corner of my square.

In another case in New Zealand, a snow-covered mountain range in the distance was separated from some autumn colored trees in the foreground by a hill which again formed a diagonal line from the upper right to the lower left. Backlit, the hillside was in complete shade, forming a strong diagonal that separated fore and background. It also served as a beautiful background for the brightly colored fall trees.

■ Shadows

Shadows can be an important part of a composition, and sometimes they are the reason for taking a picture in the first place. We all have seen or taken pictures of lamp fixtures or the decorative store signs that were common years ago, especially in Europe. Sometimes these pictures are taken because of the beauty of the sign or lamp, but probably just as often because they create a beautiful diagonal shadow pattern on the wall. It is then actually the shadow that becomes the main element of the image.

> "Shadows may ... be the focus of the composition."

Sunlight creates shadows which can fall in different directions depending on the position of the sun. With the sun in the back of the camera, the shadows fall away from the camera, which is seldom interesting. With side light, the shadows can fall either to the left or right. In backlit situations, they come right towards the camera, emphasizing and enhancing the three-dimensional aspect of the scene. In addition, such shadows can be used to lead the eye towards the main subject. Such shadow lines coming towards the camera can be changed from verticals into diagonals by simply photographing from a somewhat different angle.

Again, shadows may not only be an important part of the composition, they may be the focus of the composition.

The visual impact of the image is created by the shadow on the old wall.

14
BLACK AND WHITE COMPOSITION

■ The Black and White Print

Effective black and white images are created by an imaginative arrangement of black, white and grey shapes and lines. The whites always draw the most attention, and their placement must be watched more carefully. Black and white images can be given a different appearance by changing the contrast range, and they can be made to look completely different by eliminating the grays and making an image that consists of blacks and whites only.

The appearance of the black and white image is determined by the film we use, the development of the film and the procedure used when making the print.

■ Changing Grey Tones in the Camera

The grey tones of the different areas within a black and white picture are also determined (and can be changed) by using filters when the picture is made. From a technical point of view, the use of filters is frequently considered more for creating an image that is accepted as technically good, rather than for creating a visually different image.

"The whites always draw the most attention..."

Filters change the grey tones in a black and white image by recording different colored subjects in darker or lighter shades of grey. In order to learn and to know what happens to the different colors with different filters, just keep in mind the well known color-wheel found on page 79.

The wheel has the warm colors on one side and the cooler ones on the other. Yellow is on the opposite side of the wheel from blue, red and magenta are opposite from green and cyan. A color filter on the camera lens transmits the light rays that are the same color as the filter or are on the same side on the color wheel. The filter absorbs the colors from the opposite side of the wheel.

This means a yellow filter transmits yellow and absorbs blue. The result? The yellow filter makes yellow subjects appear lighter in the print and the blue subjects darker. That explains why we use a yellow filter to darken a blue sky. A green filter records green subjects lighter and those of red and magenta colors darker.

Using filters obviously gives us another opportunity for making black and white images different and hopefully better. We can choose to lighten certain colored areas. For example, a yellow or red filter can be used not only to bring out the white clouds in a blue sky but also simply to make the blue sky darker and less distracting at the top of an image.

Red

Magenta

Yellow

Blue

Green

Cyan

A color filter lets the light rays of the same color pass through and absorbs those from the opposite side of the color wheel. Used in black and white photography, such a filter lightens the subjects which are of the same color as the filter and darkens those that have a color on the opposite side of the wheel.

The filters can also be used to bring more details into certain areas. A green shaded area underneath a tree can be made lighter with a green filter. These manipulations with filters can reduce the need for print manipulation later in the darkroom.

■ The Polarizing Filter

A polarizing filter on the camera lens can help to produce more effective black and white and color images. The effect and the results are identical in color or black and white. Its best known application is for darkening a sky, especially a

blue sky. This application can often be very helpful. A darker sky is, first of all, less distracting because it helps keep the eye within the picture. A darker sky can also draw more attention to the other elements within the picture, making a green field in the foreground lighter than the

sky (instead of the sky being brighter than the field), for example. Keep in mind that polarizing filters darken a sky only in sidelight. Fortunately, you can always see the effect on the focusing screen of the SLR camera, or simply by looking through the filter.

Polarizing filters can reduce or eliminate the reflections on practically everything, but again only on subjects photographed from an angle of about 30 to 40 degrees. From a compositional point of view, this application can be most helpful in eliminating reflections that might

be distracting. Reflections are often extremely bright and can become an attention-creating element, even if very small. Be aware, however, that a polarizing filter does not eliminate the reflections from bare metal.

Through a red filter, the red text appears lighter than the blue background (left). Through a blue filter, the tones are completely reversed (right).

15

COMPOSING AND CREATING PANORAMIC IMAGES

◼ Composing the Panoramic Image

Basically, everything that has been discussed previously about composition also applies to the panoramic format. The panoramic format does, however, have some special requirements for producing effective images.

First, you must pay more attention to recording horizontals and verticals perfectly straight. The long and narrow image format makes the viewer more aware of tilted objects or lines.

When viewing a panoramic image, we must come away with the feeling that the image could only have been created in the panoramic format – that the scene or subject could not have been as effective in a standard aspect ratio. A panoramic image should never give the feeling that we were fascinated by the format and just tried to fill the wide image area in some way.

Perhaps we can appreciate the value and the benefits of the panoramic format better by comparing it to a pan shot in a motion picture. An effective pan must start with a strong element at the beginning, then move towards the other side and conclude with a strong element at the end. When viewing a panoramic image, our eyes should also pan over the image from one side to the other, so we need something strong at both ends of the image.

> *"...we need something strong at both ends of the image."*

Take care to create your panoramic composition in such a way that the image includes important elements that enhance the image all the way from the far left to the far right (or from top to bottom in a vertical). There must never be an empty area that is consid-ered unnecessary on either side (or on the top or bottom for verticals) of the image. In a panoramic image, more so than in an image of more "normal shape," such empty areas invari-ably create the feeling that they should be cropped off. Even worse, such areas may make the viewer question why the image was made in the panoramic for-mat in the first place.

The shape of panoramic images must also be carefully scrutinized. A panoramic image basically needs important com-positional elements only in the direction of the long format. It is the wide expanse of a land-scape or beach or the height of a waterfall or mountain that makes these images effective and different. We need not over-ly worry about filling the frame in the other direction (that is, filling the top and bottom in a horizontal, or the two sides in a vertical). As a matter of fact, reducing details in those areas (eliminating distracting ele-ments on top and bottom or on

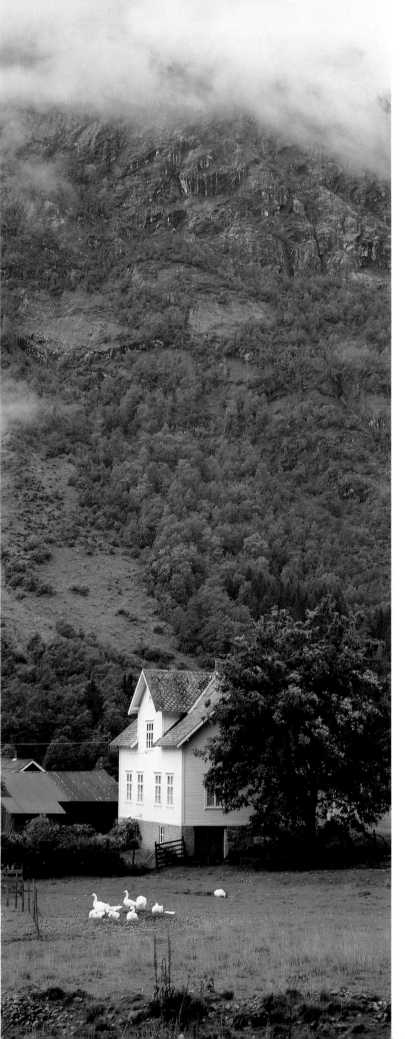

the two sides) can help to increase the effectiveness of the image.

Your one and only concern in the panoramic composition must be to assure yourself that each image includes important elements all the way from left to right, or from top to bottom in a vertical. Keeping this in mind may bring you to the correct conclusion that it is not easy to produce effective panoramics and that the panoramic format should only be considered for special images, not as an all around camera format for everything – not even everything in the landscape.

The wide-area coverage of the panoramic camera also requires paying more attention to possibly distracting elements on the sides or top and bottom of the image. From this point of view, the panoramic format has an advantage. It allows us to cover a wide area without having to include large areas on the top or bottom or on the two sides. We can easily avoid large sky areas – a nice benefit, especially when the sky is not very interesting, and possibly more distracting than helpful.

Good panoramic images feature important elements from one end of the picture to the other to enhance the effectiveness of the format. In the photo (left) of farmhouses in Norway, the clouds on top of the mountain form an important balance to the white building. In another photo from Norway (opposite), the building and hay bales fill out the frame with interesting subjects from left to right.

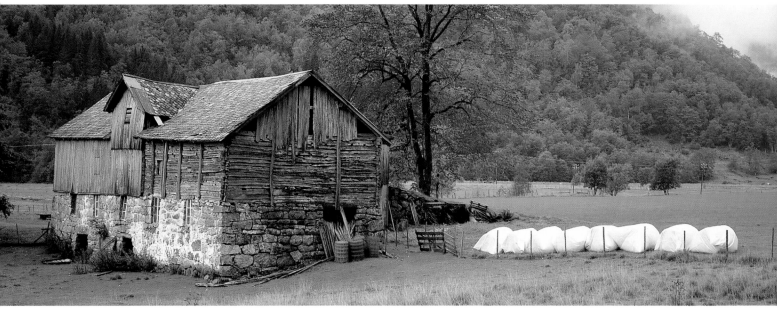

Panoramic Images without Special Equipment

You do not need special equipment in order to create panoramic images. You can create a panoramic shape from an "ordinary negative" when you make the print, or by masking a standard 35mm or medium format transparency when you mount the slide.

In this "cropping" approach, you naturally use only a small portion of the image on the film, which can make the quality and effectiveness questionable (especially in 35mm). The actual film area that you use may only be about 18x36mm.

The loss of sharpness is not as severe in the medium format where the panoramic image area from a 6x6 square may be 28x56mm, still considerably larger than the full area of a 35mm transparency.

To keep the loss of sharpness to a minimum in either format, use the sharpest low speed films.

Panoramic Images in the Large Format

A large format camera can also be used in the same way, with the advantage that you still end up with a large image of perhaps 45x90mm, 60x 120mm or 40x 120mm from a 4x5 negative or transparency. The swings and tilts of the camera can also be employed when taking the panoramic image.

When viewing the image and evaluating the composition on the focusing screen on any of these cameras, keep the panoramic composition in mind. You may perhaps want to mark the focusing screen for the panoramic shape.

Panoramic Images in the Medium Format

Panoramic images *can* be produced in medium format cameras without a panoramic mask in the camera. Such masks are, however, available for some medium format cameras.

The mask offers the advantage of having the images on the film masked for the panoramic shape, but they do not increase the number of images on the film if the film is advanced normally. You obtain twelve panoramic images in a 6x6 camera on 120 film.

If the camera has interchangeable magazines, however, you can probably eliminate this drawback by using the regular film advance crank only for cocking the shutter and then advancing the film with the winding crank on the film magazine. You may be able to obtain 23 or even 25 panoramic images on one roll of 120 film.

Creating Panoramic Images Electronically

Panoramic images can also be created by "stitching together" two or more images taken from the same camera position with the same camera and lens. This is not a new idea. Such panoramas have been created for years, but required a tedious and time consuming process in the darkroom. Things are easier

In panoramic images taken with short focal length lenses, subjects at the edges are seen from a different angle than those in the center, perhaps giving a distorted impression.

today. You can use the computer to "stitch" the images together and then print them digitally. Software for this purpose is available.

Even when working with a computer, the images that are used must still be made for this purpose, taking into consideration the same requirements that were necessary for creating a panoramic image in-camera.

Mount the camera on a sturdy tripod, preferably so the camera rotates around the optical axis of the lens. The camera must be level in all directions when the images are recorded on the film so that the horizon is also recorded perfectly level in all the images that are to be combined. The use of a spirit level is highly recommended.

Exposure, of course, must be identical. It may be best to avoid using a polarizing filter since the color in the sky depends on the camera angle in relation to the sun. This means a polarizing filter could cause the sky to appear with different shades of blue in the different images that are to be combined.

Overlap the images by about 20%. The matching of the images is usually somewhat easier when the images are made with standard or telephoto lenses rather than wide angles.

■ Panoramic Camera Equipment

Using special equipment, panoramic images can be created by increasing (not reducing) the film area. Perhaps the best known camera for doing this on 35mm film is the Hasselblad XPan. Its lenses are designed to cover the medium format, so they can also cover the panoramic format of 24x65mm that is created in this camera on any type of 35mm film.

The laboratory that processes your film must be made aware that the images are panoramic so that they do not cut the film and mount the transparencies in standard 35mm mounts. Prints from such panoramic negatives cannot be made in all laboratories, so investigate. You can also make your own panoramic prints

with an enlarger made for the 6x7 cm format.

Projecting 24x65mm transparencies requires a slide projector made for the 6x7cm format. The transparencies can also be projected in a projector made for the 6x6cm format, but only by cutting the long side of the image down to 56mm, which you probably are reluctant to do since it takes something away from the effectiveness of the panoramic image.

Special panoramic cameras are available for producing panoramic images on 120 or 220 rollfilm. Two popular panoramic medium formats are 6x12 cm and 6x17 cm.

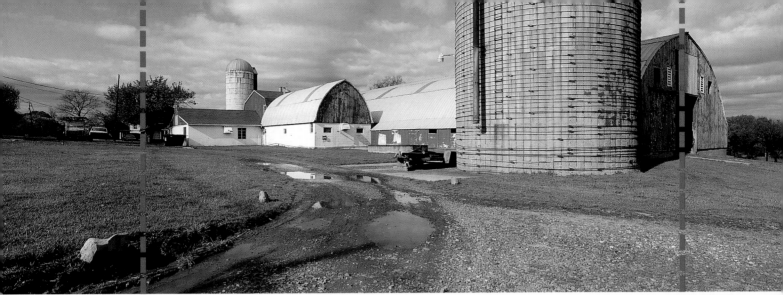

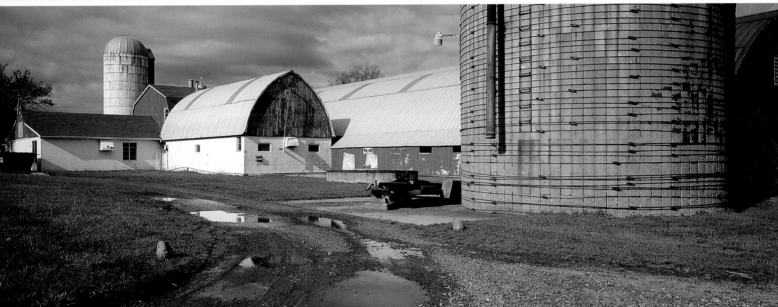

The image at the top is poorly composed with unimportant, empty areas on the left and right that could be cropped (from the red lines to the edges of the frame). Using a longer lens produced a more effective panoramic composition (center image), with important subject detail filling the image area from left to right.

In the bottom pair of images, the photograph on the left has empty space at the bottom which reduces the effectiveness of the panoramic format. On the right, a different, more effective composition is used, with a rock and flower bed filling the bottom area.

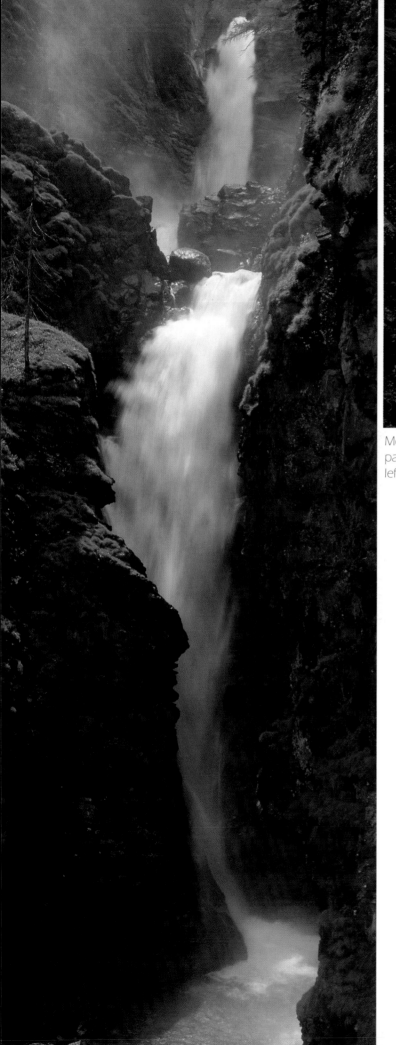

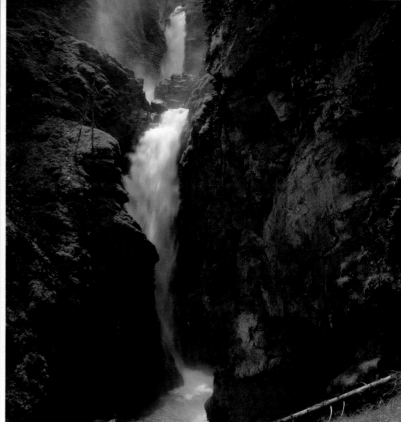

Medium format images (above) can be changed into effective panoramic shaped images either vertically (as in the image on the left of a waterfall in Switzerland) or horizontally.

16

CREATING EFFECTIVE IMAGES IN OTHER WAYS

Following all the points that relate directly to composition will result in a image that is at least pleasing to view. Every photographer has additional opportunities for improving a photographic image further and making it visually more effective. These additional possibilities are the options we have with our camera and lens settings and with our films to record subjects in a different, hopefully more striking fashion. They are covered here because they must be considered when creating the image as much as the compositional elements; they must work hand in hand with composition and, in a way, become part of the composition.

In most cases we must consider both possibilities, but often we can use one instead of the other. For example, instead of trying to improve an image by changing the arrangement of subjects or eliminating a distracting subject based on the compositional suggestions, you might find that simply changing the size or the sharpness of that subject is an equally good, simpler (or perhaps even better) solution.

> *"...these points also offer image creating possibilities..."*

The possibilities that cameras and lenses provide are usually covered in the technical chapters of camera use and operation because they must be considered mainly for the purpose of producing an image that looks its technical best. These points are helpful even when considered mainly or only for technical reasons – because a technically good image is also likely one that is visually satisfying.

But, like the arrangement of lines, shapes and colors, these points also offer image creating possibilities and must be considered in the overall image evaluation. They must become part of our image creating process and be considered whenever we compose an image in the viewfinder or our camera.

17

SELECTION AND USE OF LENSES

■ The Standard Lens

On a point and shoot camera (film or digital), you may be limited to a "standard" lens that has a focal length about equal to the length of the diagonal of the image format for which the camera is designed. Such a lens records the scene pretty much as our eyes see it, as far as the size relationship between fore and background is concerned. A barn in the distance that we see as being about 1/10 the size of a closer building will appear on the film in about the same size relationship. This size relationship is known as perspective.

With such a single focal length lens camera, you can go closer to a subject to record it larger, and doing so also changes the perspective. By photographing a foreground fence from five instead of ten feet, the fence appears to be twice as large without appreciably changing the size of the background.

Always consider the background carefully. Don't just look at the main subject, but also check what is in the background when time permits a more careful image evaluation. Watch mainly for elements that distract, such as bright areas. Usually a change in the camera angle (often just a minor change) brings a different, hopefully better background behind the same main subject.

> "Watch mainly for elements that distract..."

Since a standard lens allows you to cover a smaller area only by photographing from a closer distance, always look for the possibility of creating another, perhaps better image by going closer. Most photographers have a habit of covering too much, photographing from too far away and completely forgetting the slogan "less is better."

■ Background Area Coverage

Different focal length lenses or zoom lenses allow covering smaller or larger areas from the same distance. For most photographers, this is the main (and sometimes the only) reason for changing lenses or changing the focal length of a zoom type.

While this is a good and necessary reason for selecting a specific focal length, from an image creating point of view the choice of focal length should more often be made for the desired background area coverage. We can create a good full length picture of a model with wide angle, standard and telephoto lenses or with the shortest, medium and longest focal length setting on the zoom lens. We simply go closer to the model with the shorter lenses or lens settings or photograph the model from further away with the longer lenses or lens settings. While this approach maintains the model's image on the film, the overall

The standard focal length lens recorded this harbor scene with its strong leading line on the left as seen with our eyes.

image will not be the same. Taken at the shorter focal lengths, the image will include a large background area. With longer lenses, the background area will be reduced to what is directly behind the model.

> "...the background is a major part of the image..."

In many images taken outdoors or indoors, the background is a major and important part of the image. How much of it we include may determine the effectiveness of the picture.

Background coverage at different focal lengths must become of primary concern to a serious photographer. A historic building photographed with a shorter focal length lens may include a sky area above the mountain range in the background, which may very well be distracting. A longer lens eliminates the sky and reduces the background to nothing more than the different colors on the side of the mountain. Photographed with a longer focal length lens, the background behind an old mill may include part of a light colored farm structure. With the building recorded relatively large, it could become almost a secondary main subject and may be distracting because of its light color. Photographed at a

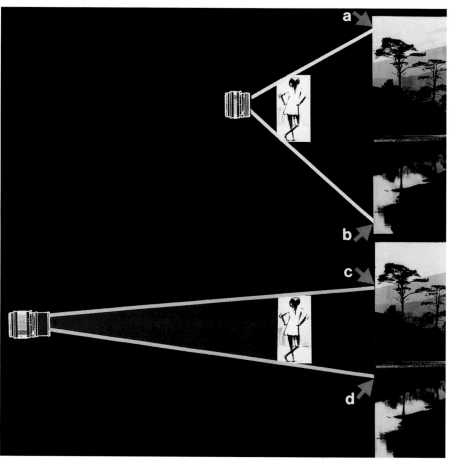

A picture of a model taken with a short focal length lens includes a large background area (top). Photographing with a longer focal length lens from a longer distance keeps the model the same size, but includes a smaller background area (bottom).

shorter focal length, the farm building may be small enough to appear more like a background element.

What do we learn from this? Always make background evaluation a part of your overall image evaluation. Check not only what is in the background, but also try to determine whether including more or less might improve the picture.

■ **Longer Focal Lengths**

A primary benefit of using a longer focal length is the possibility of eliminating objectionable or distracting subjects in the background (cars, people, advertising signs) without having to change the camera position, which is sometimes difficult or impossible to do. Since longer focal lengths include smaller background areas, they offer more and easier possibilities for changing what is visible in the background. The distracting element can often be eliminated with just a minor camera movement to the left, right, up or down – with the main subject still photographed from basically the same angle.

In the studio, longer focal length lenses allow working with smaller backdrops. A lens that has twice the focal length

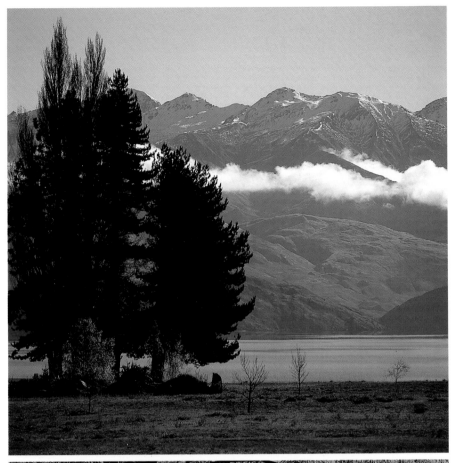

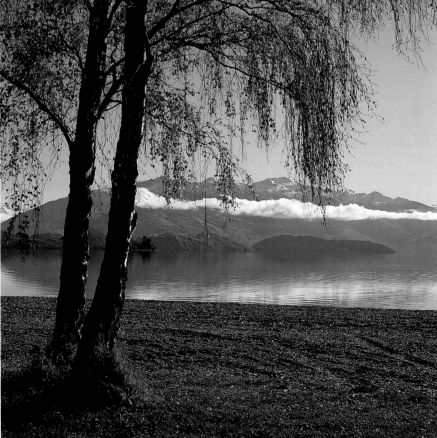

of the standard type requires a backdrop that is only half the usual width and height – a nice benefit, especially in full length model or portrait shots.

◻ Shorter Focal Lengths

While longer lenses are usually used to reduce the importance and dominance of background areas, shorter lenses help to make the background a more important part of the picture. The larger background helps to establish a location, emphasizing where the picture was taken. The shorter lens allows inclusion of an entire, recognizable mountain, or an entire recognizable historic building or area. The background becomes part of the image. The importance of the background in relation to the main subject must therefore become a major reason for photographing at shorter focal lengths.

With a shorter lens, moving somewhat to the left or right, up or down, changes little in the background coverage. Eliminating a distracting subject may require photographing the main subject from a different, perhaps undesirable, angle.

The possibility of eliminating distracting background elements at different focal lengths perhaps illustrates best how

With a telephoto lens (top), the mountains in the distance appear much larger, closer and majestic than we see them with our eye or in an image (bottom) taken with a standard focal length lens.

closely composition is tied together with the use of cameras and lenses. We can frequently accomplish basically the same goal with either one or the other: we can eliminate a distracting background element either with a different composition (photographing the subject from a different angle) or by photographing from the same angle but at a longer focal length.

■ Background Subject Size

Different focal length lenses also determine the size of the background subjects. With a lens that has double the focal length of the standard type, background subjects will appear twice as large. The main subject (the person, the building, the fence in the foreground) can be recorded in the same size by photographing it with the longer lens from twice the distance – perhaps twenty feet instead of ten.

Different focal length lenses used from different distances thus make it easier to change the size relationship between fore and background, which means changing the perspective in our pictures. With longer focal length lenses, background subjects appear larger and closer; shorter lenses record them smaller – they appear to be further away. This change of perspective is very obvious in a photograph, more so than when viewing the scene with our eyes. Consequently, you can use this advantage to make your photographic images dif-

ferent from the way we see the subject with our eyes.

Different focal length lenses allow us to make background subjects a more or less recognizable part of the image, thus making our images visually more or less effective. With a shorter lens, a broken down barn in the background may be included from top to bottom. The barn becomes a rather dominant part of the photograph. With the lines in the barn going in all different directions, it may even become a distracting element in the background. With a longer lens, the background may include nothing more than some vertical wood panels on the front of the old barn, making the barn a subdued, hardly recognizable (and certainly not distracting) backdrop.

" ... change the size relationship between fore and background..."

Longer focal length lenses offer wonderful opportunities for making background areas more dominant, which works especially beautifully with a distant mountain range. A mountain range that may be hardly recognizable in the distance with our eyes or when photographed with a standard focal length lens becomes five times larger and much more majestic by filling the entire frame

when taken with a lens 5x the focal length of the standard.

The decision regarding the size of the background subject may be made strictly from a visual point of view, or may be based on the purpose of the picture or what the image is to convey.

You may want to use this possibility to establish a size relationship. Enlarging the background subjects by using a longer lens can help emphasize the small size of a foreground subject. This approach can work well when photographing a small child, for example. Conversely, the large size of a foreground subject can be further enhanced by photographing it against background subjects that are made to appear smaller by using a shorter focal length lens.

Make a habit of viewing the subject through different focal length lenses or a zoom lens set to different focal lengths before you take the picture – or at least before you pack up and move to the next location.

■ Background Sharpness

Background subjects that are within the depth of field range are recorded sharp on the film (or electronic chip), whether we use a shorter or a longer focal length lens, at least for "general purposes." I add "for general purposes" because the critical photographer must be aware that depth of field range does not mean "perfect" but "acceptable" sharpness. There is a reduction of sharpness within

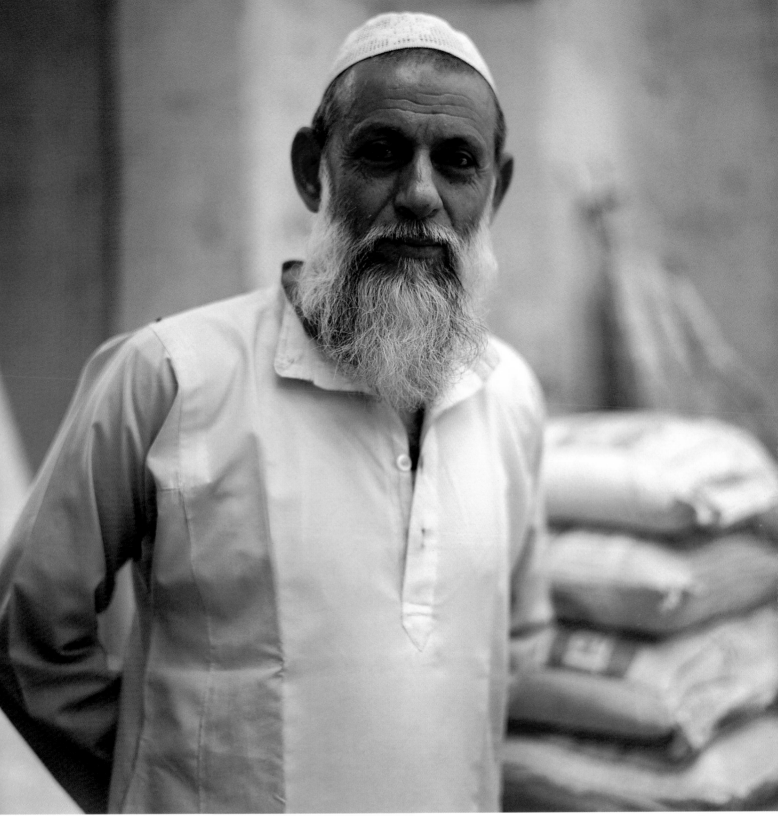

A sharp, or reasonably sharp, background helps to reveal the location of the image. This is often helpful in location portraits, such as this photograph shot in a marketplace.

the depth of field range. Only the subject that is precisely at the focused distance is perfectly sharp, at least under a critical image evaluation with a 10x magnifying glass. Anything closer or further away (even within the depth of field range) is not as sharp but has (again, for general purposes) an acceptable sharpness.

This is true for any focal length lens, but the sharpness differences are more obvious in images taken at longer focal lengths. The differences are also more obvious on the larger medium format negative or transparency.

I am mentioning this fact here mainly because I find more and more photographers - especially those working in the medium format - who become aware of these differences and often feel that their lenses do not have the depth of field that is indicated on the engraved depth of field scale. The lens and lens design has nothing to do with depth of field. We have become more aware of these differences today because the modern films are sharper and make such differences more obvious. For general image creating purposes, however, we can still say that a background that is within the depth of field range is sharp with any lens.

If the background is beyond the depth of field range, the situation is different. We can change the sharpness of the background by using different lenses because the background

now appears more or less sharp depending on the focal length of the lens. A shorter focal length will keep the background reasonably sharp and recognizable while a longer focal length will blur the background more and possibly make it virtually unrecognizable. To say it in a different way, different focal length lenses also give us the possibility of changing background sharpness -- which in turn gives us another great possibility for making our images (especially outdoor images) more effective.

"... decide how the background should be recorded..."

A distracting background subject can be changed into a hardly recognizable blur, a disturbing blur can be changed into a recognizable part of the background. You, the photographer, must decide how the background should be recorded, and you must do so when evaluating the image in the viewfinder. Using a blurred background should be considered when the background is an unimportant part of the image - more like a backdrop behind a portrait, perhaps. Blurred backgrounds are usually best behind head and shoulder portraits. Keep the backgrounds reasonably sharp when they are a more important part

of the image (when you want to identify the location, for instance).

This image evaluation is possible only on a single lens reflex (SLR) or large format camera where you view the image through the lens and where you have the possibility of manually stopping down the lens aperture. Use this control. Evaluate the scene or subject not only with the lens aperture wide open, as it is usually. Use the manual stop down control so you can see the image in the viewfinder at smaller apertures. Observe how the background sharpness increases as the lens aperture is stopped down, how it blurs when it is opened, and then decide which aperture provides the desired image. When in doubt, take the same shot at different apertures (with a change in shutter speed to provide correct exposure) and then decide later which one is visually most effective.

Such complete and detailed image evaluation is possible on single lens reflex cameras (SLRs) in any film format but is especially effective on the larger focusing screen of medium format types. The camera must also have a manual aperture stop down control, which I consider a most helpful and valuable lens control feature for serious photography.

■ Foreground Sharpness

Foregrounds are also part of most of our images and they can be definite, easily recognizable subjects (railings, bushes, street signs) or they can be nothing more than an object (a meadow, a body of water) leading the eye towards the subjects in the background. Just as with backgrounds, the degree of unsharpness in foreground subjects is determined by the lens aperture and the focal length of the lens. Generally, easily recognizable subjects and subjects with sharp outlines, (straight lines such as fences, rocks, furniture) look best when recorded as sharp or reasonably sharp. If blurred, such subjects may look more like a distracting mess.

On the other hand, subjects with more graceful, curved lines (and especially colorful subjects such as flowers or fall leaves) that appear completely blurred in the foreground can add a beautiful touch to many pictures. Placed at the bottom or the sides, such blurred subjects can add a beautiful touch of color to an outdoor portrait, for example. Such foreground subjects are most effective when completely blurred, so the image gives the impression that they were included for a purpose. If such subjects are blurred just a little, your image may convey the feeling that the foreground subjects are there by mistake.

This is a situation where long lenses used at a large apertures can do wonders. Such

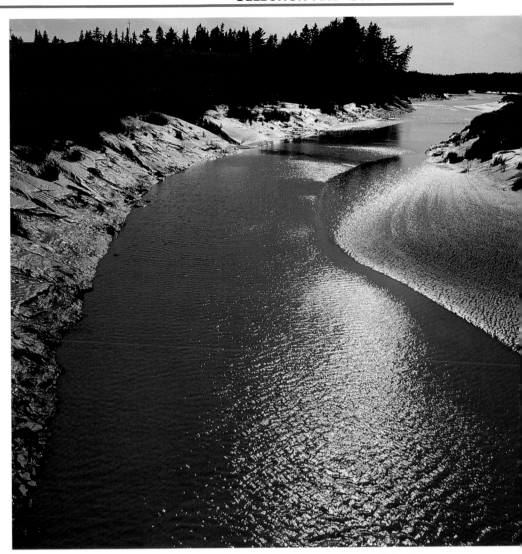

This wide angle image was taken with a 50mm lens on a Hasselblad camera (equivalent to about a 33mm focal length on a 35mm camera).

lenses, even used in a scene with nothing more than a meadow in the foreground of an old barn, can emphasize the extent of the landscape by making the meadow from a complete blur to complete sharpness in front of the barn. The complete change in sharpness within the meadow may produce a visually more effective photograph only because we cannot not see this sharpness change with our eyes. Everything from fore to background looks sharp to our eyes.

■ Effective Use of Wide Angle Lenses

Wide angle lenses, or short focal length settings on a zoom lens, should be considered not only for the purpose of covering a larger area but also for enhancing the three dimensional aspect of a scene. You can accomplish this by composing the scene so it includes foreground areas. The foreground subjects can be quite dominant and recognizable (such as rock formations, a flower bed, a tree stump or a fence), or can be a

more natural part of the scene (a field, a body of water, weeds in a swamp or the sand or stones of a beach area). Including such areas in the composition where they fill in a good part of the total image enhances the depth and three dimensional feeling of the scene. This is especially true with wide angle lenses, as the shorter focal length also emphasizes the size relationship between fore and background, and makes the background sub-

jects appear to be further away than they actually are. The result: a "true" wide angle shot.

■ Effective Fisheye Lens Photography

Fisheye lenses come in two completely different lens designs. One type produces a circular image that only covers the center portion of the film area. I feel that such lenses have limited application in serious photography. The attention is mainly created by the circular

shape of the image, not so much by the image itself. As a result, practically all the images look alike, regardless what the subject might be. The subject in the circle becomes secondary.

The other type of fisheye lens design is known as a full frame type. As the name indicates, such lenses cover the entire film area for which the camera is designed. Such full frame fisheye lenses are available for 35mm and medium format cameras. They can be an asset for creating different compositions, different images of any subject. Full frame fisheye lenses are great tools for creating something unique because they create an image that looks different from the way we see the the same scene with our eyes. Use them for that purpose.

The different view is created by the fact that the diagonal angle of view (which is usually 180 degrees) is completely out of proportion to the vertical or horizontal angle of view of a wide angle lens of the same focal length. The fisheye lens shows us more diagonally than we would see with a wide angle lens, and even with our own eyes.

Since the diagonal angle of view is out of proportion, straight vertical or horizontal lines off the center axis are recorded as curved lines. The further away from the center, the more curvature the lines have. That is what gives such images the typical fisheye look. The beautifully curved lines

Wide angle pictures are more effective when composed to include foreground areas that enhance the feeling of depth and distance. Such images are usually best when everything is sharp from fore to background.

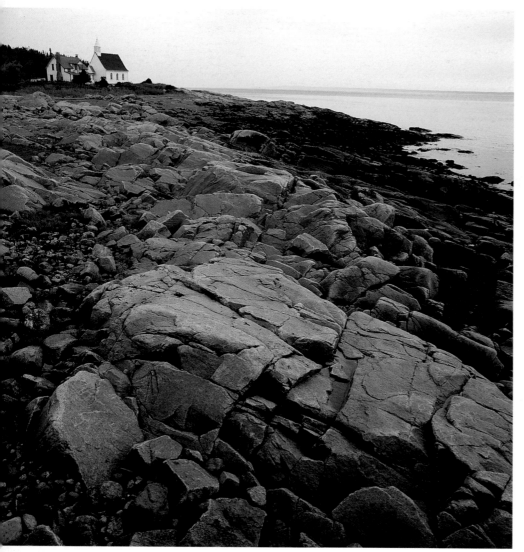

that the fisheye lens produces are usually the first reason for considering such lenses. If used for that purpose, I suggest that you try to emphasize the effectiveness of the curved lines. Use the lens where the curved lines add visual impact. At the same time, keep in mind that the image must convey the feeling that the fisheye lens was used for a good reason, not just to be different.

For creating effective fisheye images, subjects must be carefully chosen. Select subjects where the fisheye look may create the proper mood – in an amusement park, perhaps, or for a portrait of a clown. Good composition is of utmost importance in fisheye images. Full frame fisheye images are usually effective when equally curved lines appear on both sides of the image (or on top and bottom) regardless of what the image format might be.

If you compose a building so it covers mainly the left area of the image, the curved lines will be dominant or exist only on that side. This can easily look lopsided, unnatural or disturbing. When photographing a building from the outside (or the interior of a building or cathedral), the most effective fisheye image is created when

The curved lines produced by fisheye lenses can easily look gimmicky and attract unnecessary attention, as in the top image. Fisheye lenses are best used when the curvature of the subject enhances the visual effect, as in the bottom photograph shot at Boulder Dam.

the center of the building or cathedral is also in the center of the image. The walls and windows on both sides of the building, the pillars, or the stained glass windows in the cathedral then appear equally curved on both sides.

A fisheye image of a group of trees is likely most effective when a dominant tree is exactly in the center with similar trees on the left or right side. Take your time composing such images on the focusing screen. Make certain that the center of the subject is exactly in the center of the focusing screen, as even a slight trace of curvature may be objectionable in the final image. Look for some kind of repetition of curved lines on both sides of the image.

If you use full frame fisheye lenses extensively, you may want to consider putting vertical and horizontal lines in the center of the focusing screen if they do not exist already. Instead of lines, at least mark the center of the focusing screen on both sides, on top and bottom.

■ Fisheye Images with a Non-Fisheye Look

Composing fisheye scenes with a vertical or horizontal line perfectly in the center usually works because the center line is straight, not curved. With a full frame fisheye lens, horizontal, vertical or diagonal lines going exactly through the center of the frame always appear perfectly straight on the film. A round subject, such as the face

of a clock for instance, composed in the center of the frame will be recorded in a perfectly round shape. I have photographed the double arches in the Arches National Park in Utah with such a lens pointed straight up to the sky.

Such a fisheye image may then differ from a wide angle picture only in its diagonal 180 degree area coverage. This large diagonal area coverage came in handy when photographing the double arches. Using a diagonal composition, the fisheye lens allowed me to cover the arches

from bottom to bottom without the typical fisheye look. No wide angle lens would have accomplished this.

Images with this "non-fisheye" look can be created in many locations and can be a second reason for using such lenses. The horizon line in a landscape composed to go exactly through the middle will appear perfectly straight. Buildings, trees on the left or right will have curved verticals, but if the buildings or trees are not too large, the curvature may be hardly recognizable.

The tree trunks composed from the corners of the image appear straight – hardly revealing that the image was made with a fisheye lens.

18

PORTRAIT BACKGROUNDS

■ Studio Portraits

Studio portraits are generally taken in front of a backdrop of a specific color, or with a pattern of different colors. White is a popular choice for fashion work and is necessary for high key pictures. For general portraits, you are likely to choose something darker that emphasizes the person's features and presents the person in the most effective fashion – the main objective for a successful studio portrait.

■ Location Portraits

The considerations must change, at least in my opinion, when we take portraits on location. The last thing you want to do is to duplicate on location what you would do in the studio. The reason for doing the portrait on location is to come up with something different.

First, do not try to duplicate the studio lighting. Take advantage of the beautiful possibilities that exist outdoors (or with existing light indoors) to pro-

duce something different with the true location look. The possibilities are unlimited – from the warm early morning light, or the soft light in a fog-covered landscape, to the brilliant light on a sunny day. Each gives the portrait a specific mood and feeling.

> "Each gives the portrait a specific mood and feeling."

Instead of selecting a shaded area on a beautiful sunny day, you may want to take advantage of the sunlight. Use it in an effective fashion (perhaps as a back or hairlight) while filling the shaded areas with flash. I recommend this approach especially for photographing young people. The sun enhances the happy mood that should be part of a young person's life.

Do not try to duplicate a studio backdrop when you work on location. Refrain from backgrounds like an evergreen tree which, when slightly blurred, looks little different from what we have in the studio. Make the location portrait a true location portrait. Make the surrounding area and the background an important part of the picture.

Select the location carefully, taking into account what the person will be wearing. A casual outfit obviously calls for a different location than a formal outfit. For an informal outfit, you might select an old barn; for a bathing suit, you might chose a location where you normally walk around in a swimming outfit. A modern or historic building and stairs are good locations for more formal attire.

Of course, you may also choose to work the other way around, selecting the location first and then telling the model what to wear.

■ Selecting a Focal Length

Whatever the location, the background (and especially the background area that is covered in the picture) must enhance the final portrait. This means the choice of focal length must also play a major role in making the portrait.

A longer focal length lens with its smaller background coverage can provide very beautiful backgrounds that may be somewhat subdued, without necessarily conveying a specific location.

The large background area coverage of the shorter focal lengths make wide angle lenses great tools for outdoor portraiture. Using a wide angle lens, we can include the entire church (or at least a good portion of it) behind the bridal group. With a wide angle or fisheye lens, we can include a large portion of the church's interior behind the portrait of the bride and groom. These wonderful possibilities explain why wide angle lenses, even fisheye lenses, are used extensively today by the best known outdoor portrait photographers. These lenses offer the possibility of making location portraits really different, giving them the real location look.

The size of the background area coverage can be further enlarged by photographing in the square format, which gives additional space and background coverage on the two sides.

■ Avoiding Distractions

Needless to say, one must naturally be careful in location portraiture to avoid anything in the background that might be distracting or that does not fit into the background of the portrait.

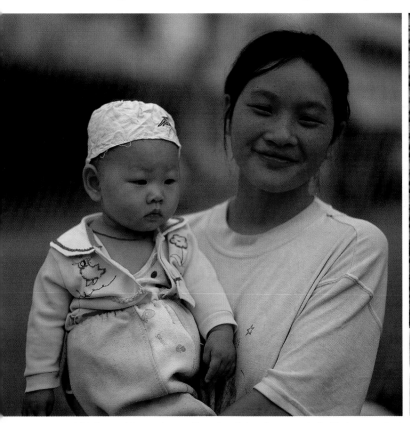

While a blurred, undisturbed background (left) is usually best for people pictures (as in this candid shot on a street in Chengdu, China), the opposite is often more effective when the background is to be part of the image (right), as in this market scene in Mexico.

19

LENS AND CAMERA CONTROLS

Every camera has aperture and shutter speed controls that are used each time we take a picture. In some of the modern tools that we have available today, the camera itself may determine and set both of these controls without giving the photographer the option to do so. They are set automatically by the camera, simply for the purpose of providing a good exposure. In most situations, the results (the exposures) are amazingly good. Such cameras are good tools for snapshooting souvenir pictures and family pictures where we expect nothing more than a technically satisfactory picture.

For creating pictures for more serious applications, photographers must be able to decide on the aperture and shutter speed and set them based on the desired results. Unfortunately, some photographers working with cameras that provide these opportunities for manual control use them only for the same techni-

cal purpose that the automatic cameras do – to come up with a properly exposed negative or transparency. These photographers completely forget that both the aperture and shutter speed controls offer the greatest and simplest possibilities for creating images with visual impact and for changing images to make them visually more effective.

> "...lens aperture determines the range of sharpness..."

Here's the nicest part: the two controls are part of every camera used for serious photography. There is nothing else to buy or add to what you already have.

■ Sharpness Range

The lens aperture determines the range of sharpness

known as depth of field. The aperture is one of the greatest controls we have to make our images visually more effective. It is also a control that directly relates to the way we compose our images.

Don't overlook this control when creating your images. Don't, for instance, decide on a certain aperture just to achieve correct exposure. Instead, set the aperture for the desired sharpness range and then try to match the shutter speed to expose the negatives or transparency properly.

I suggest this approach because selecting the sharpness range is important for most of our images. I feel that aperture selection must usually come before shutter speed selection. For this reason, I prefer automatic cameras that offer aperture priority.

Whenever possible and practical, evaluate the scene visually and try to determine whether everything from fore to background should be as

A shallow depth of field makes the image different than we would see it with our eyes. Here, the viewer is forced to look at the brown leaf because it is the only sharp subject and the only subject with brown coloration.

sharp as possible or whether the image might be more effective if the sharpness is limited to a certain area, leaving fore and/or background more or less blurred.

If you work with a single lens reflex (SLR) or large format camera, this evaluation can be made in an effective fashion on the camera's focusing screen. Seeing the image through the lens, you can actually see how the sharpness range changes as you open or close the lens aperture, and you can see how much blur is created in the fore and/or background at the different lens apertures.

In a room interior, you probably want everything sharp. Furniture just does not look right when it is out of focus. The

same applies in outdoor scenes with well defined foreground subjects, such as wood or stone fences, rocks, a boat, a wagon or a person. You usually expect to see such subjects sharp. On the other hand, flowers, weeds and grasses can be more effective when blurred.

While making the evaluation of the sharpness range, also pay close attention to the degree of sharpness or unsharpness in the fore and background. Decide whether fore and backgrounds are an important part of the picture and should relate to the main subject (in which case you want to try to keep it reasonably or completely sharp), or whether a background should be more like a "backdrop" (which calls for a good amount of blur).

Check whether certain lens apertures, with the resulting degree of sharpness range, can

Sharpness from foreground to background is usually best for architectural photographs.

While sharpness over the whole image area is usually best for pattern pictures, the results are never completely predictable, and sometimes based on personal preference. Photographing such scenes both with the lens wide open (left) and completely closed down (right) is recommended.

help to guide the viewer's attention within the picture. In a picture where everything is sharp, the viewer's eye can roam around anywhere within the picture, guided only by the attention creating qualities (the shape, size, color and brightness) of the various elements. In a picture with a limited sharpness range, the eye is also guided by the degree of sharpness and unsharpness in the various elements. If only one area or subject is sharp within the image, you can be certain that the viewer's eye will immediately be attracted to this one sharp subject or area. You practically force the viewer to look at that part of the image.

Limiting the range of sharpness can be your most valuable image creating element to guide the viewer's attention and to convey to them what you feel is most important in the image. Longer focal length lenses can be especially helpful for achieving this goal, since the unsharpness in front and behind the focused area falls off more rapidly.

■ **Distracting Elements**

Also check whether certain lens apertures help to eliminate or reduce the distraction of disturbing areas. The degree of sharpness or unsharpness can make these areas more or less distracting.

While a single sharp subject surrounded by unsharp areas always attracts attention, the opposite is also true. A single area that is blurred in an otherwise sharp image can also create attention; such an area can add or distract from the visual impact. A clearly visible but blurred boat in the background or a brightly colored but blurred toy in the foreground can become attention creating – and perhaps distracting – elements.

Fortunately, a single lens reflex (SLR) camera allows you to see the degree of sharpness and unsharpness in the various parts of the composition. You just need to spend the time to

make a careful image evaluation at the different lens apertures. This must be part of evaluating the composition.

Of course, the image on the focusing screen is small, especially on a 35mm camera, and some distracting elements may not be as obvious as they will be on an enlarged print or when the slide is projected on the screen.

■ Depth of Field with Different Lenses

Depth of field on any camera in any film format is determined by the focal length of the lens and the lens aperture. The depth of field range is a calculated figure based on the film format for which the lens is used. Lens design and lens quality are not involved.

It is often said that shorter focal length lenses have more depth of field than those with longer focal lengths. This is correct, but only if the different lenses are used from the same distance – that is, if you switch from wide angle to standard to telephoto without moving the camera. In this situation, however, the three lenses also cover larger or smaller areas and thereby create three completely different images. In spite of the different area coverage, there are cases where you may decide on a specific focal length simply based on the desired depth of field. You may use a wide angle for a landscape because it is the only lens that provides sharpness from fore to background. You may

select a longer focal length lens simply because it is the only one that blurs the background sufficiently.

We must also consider depth of field when different lenses are used to cover the same size area – a situation that comes up most often in practical photography. When photographing a portrait, a close-up of a flower, a product or a building, the subject size (and thus the area of coverage) is pre-determined.

We can use different focal length lenses from different distances to cover the same area and "fill the frame." In this situation, every focal length lens used on the same camera has the same depth of field. Depth of field is determined only by the area coverage (magnification) and lens aperture. While the range of sharpness is the same, the subjects beyond the depth of field (i.e. the background) will have more blur with a longer lens, or appear sharper when taken with one of a shorter focal length.

■ Determining Depth of Field

Being able to see the depth of field on the focusing screen is often pointed out as a main advantage of using a single lens reflex (SLR) camera. This statement is correct, but only in theory.

The depth of field range is the range of distances within which a subject will appear with "acceptable" sharpness when the transparency is pro-

jected, or the negative is enlarged to a print of perhaps 16 inches. Since the single lens reflex (SLR) camera allows us to see the image through the lens aperture and with the lens aperture at different settings, we can see the image on the focusing screen as it will be recorded in the camera. We can also see how the degree of sharpness changes as the lens aperture is closed or opened.

Seeing depth of field, however, is another matter. Compared to the size of the final print or the projected transparency, the image on the focusing screen is small – very small, only (24x36mm) on a 35mm camera. Furthermore, focusing screens frequently have a pattern that makes seeing fine detail even more questionable. As a result, there is no way that we can see on this small image whether the image sharpness will or will not be acceptable on the large print, or at what point within the scene the sharpness changes from acceptable to unacceptable.

The focusing screen is wonderful to assure that the main subject is sharp and to see how much sharpness or blur exists in the back or foreground. The depth of field must, however, be determined from the engraved scales on the lenses.

It is also worthwhile pointing out that the depth of field charts that we use today were calculated thirty or more years ago and are based on the quality and sharpness of the films that existed at that time. The

films that we have today are much sharper, making the fall-off in sharpness within and beyond the depth of field range much more visible, and the difference between acceptable and unacceptable sharpness more obvious – at least in critical image evaluation under a 10x magnifying glass.

◼ Handheld Photography

With 35mm and medium format cameras, pictures can be taken either handheld or on the tripod.

I believe that photographers working with such cameras should not be tied to one or the other approach – for example, insisting on using a tripod for everything. These cameras are ideal for either approach, and you should select the method that allows you to create the desired results in the best way. The decision must frequently be based on practicality – mainly the focal length of the lens and the possible choices of shutter speeds. In many other cases, it must be based on the subject we are photographing or the desired results.

For photographing people (for instance in a candid shot of a marketplace) only the handheld approach works. Insisting on a tripod would mean missing all the wonderful opportunities for capturing real life pictures. The results would be posed picture postcards.

For landscape photography, with shorter or standard lenses, either approach is usable. The handheld approach can only be

For candid, handheld work, a lens with a focal length a little longer than standard is my choice. This photograph was shot in Mexico with a 150mm lens on a Hasselblad medium format camera (equivalent to a 90mm in 35mm format).

considered if the scene is fairly bright so that we can use shutter speeds short enough to eliminate possible image blur due to camera movement. The longer the focal length, the shorter the shutter speed must be to eliminate (or at least reduce) the danger that camera motion will show up in the picture. The handheld approach

is usually a good choice for flash pictures, since the flash duration is short and eliminates blur (at least in the main subject).

Scene brightness and shutter speed are only two (and not necessarily the most important) considerations in determining whether to use the handheld or tripod approach. The effect that

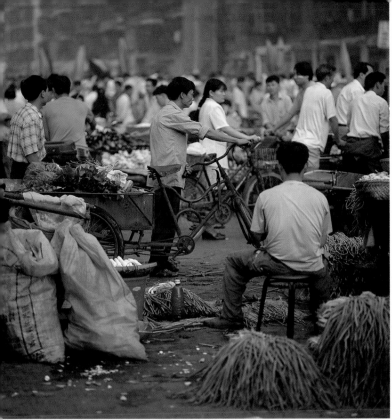

Using a faster film (ISO 400) allowed handheld photography in a dark marketplace in Seoul, Korea (top, right). The shallow depth of field caused by the large lens aperture is the main limiting factor to handheld work. The narrow sharpness range can be objectionable (top, left), or helpful (bottom, left).

we want to create in the image, especially the sharpness range that we'd like to achieve, must be the main consideration.

The lens aperture determines the sharpness range. The relatively short shutter speeds necessary for handheld photography usually require large lens apertures that produce a narrow depth of field.

To take a picture at 1/125 sec. on an overcast day on 100 ISO film, the required lens aperture for correct exposure may have to be f/8. A short telephoto of about 90mm on a 35mm camera (150mm in the medium format) may have depth of field of only 10 to 25 feet at this aperture. We really have no opportunity of increasing depth of field unless we want to take a chance and photograph the scene at 1/30 sec. or 1/15 sec. I am usually reluctant to do so because unsharpness due to camera motion is more visible and objectionable on the sharp films that we have today.

Consequently, the main limitation for the handheld approach is not so much the capability (or incapability) of holding the camera steady, but the limited choice of lens apertures – thus the limited choice in the sharpness range within the picture. In most cases, your decision of whether to work handheld or with a tripod must be based on the desired range of sharpness, and thus the needed lens aperture. Working on a tripod gives you more freedom to use the entire aperture range, thus utilizing all the image creating possibilities offered by that lens.

■ Hyperfocal Distance

When the focusing ring on a lens is set at the distance where the depth of field extends to infinity, the lens is set to what is called the hyperfocal distance. Set to the hyperfocal distance, a lens gives the maximum possible depth of field at that particular aperture.

Since most lenses used for serious photography have depth of field scales engraved, it is not necessary for you to know what the hyperfocal distance is at the different lens apertures. Simply turn the focusing ring of the lens until the infinity mark on the focusing ring is opposite the aperture marking on the depth of field scale that corresponds to the aperture that will be used for the picture.

If you want to know the hyperfocal distance, it is the distance that is now opposite the index mark. The minimum distance of the depth of field range is found opposite the corresponding aperture marking on the left side of the index. You will find that this minimum distance is half the distance that is opposite the index mark.

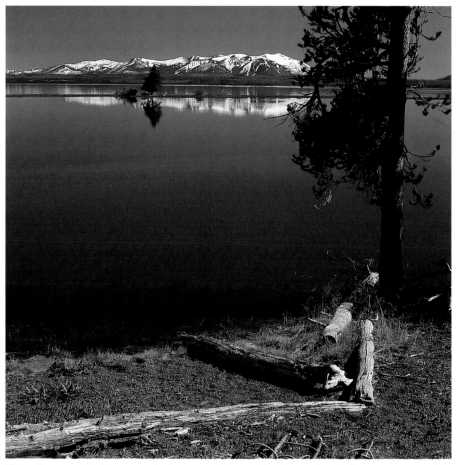

This picture at Yellowstone Lake was taken at the hyperfocal distance to provide sharpness from the distant mountains to the log in the foreground.

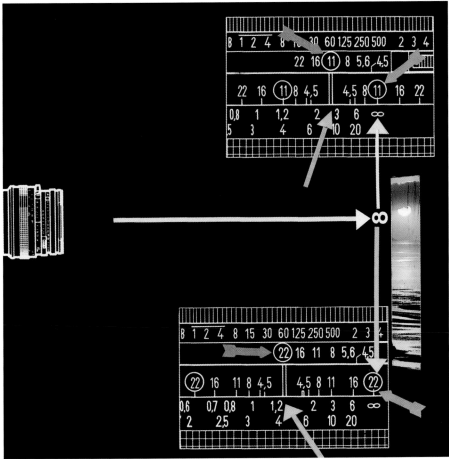

A lens is set to the hyperfocal distance when the infinity mark on the focusing ring is set opposite the corresponding lens aperture engraving on the depth of field scale.

■ Extending the Range of Sharpness

Depth of field is determined solely by the focal length of the lens and the aperture setting. The range of sharpness that will appear in the final image, however, can also be changed and increased by tilting the film or lens plane in relation to the other. This additional option is possible with any lens and at any lens aperture, if the tilting capability exists.

Depth of field and range of sharpness are completely unrelated. You can, for example, create a practically unlimited sharpness range by tilting the film or lens plane, and take the picture with the lens aperture fully open. It is worthwhile mentioning here that tilting the film or lens plane is completely different from shifting the lens or film, which was discussed under perspective control.

Both controls – tilting and shifting – exist in large format cameras where you usually also have the choice of shifting or tilting the film or the lens plane. This possibility, however, is no longer limited to large format photography. In 35mm, tilt capability exists in a few special lenses. In the medium format, the tilting is accomplished either with a bellows connection between camera and lens, or, more often, with a special camera body built around a bellows. The Hasselblad Flexbody is what I use for this purpose.

When working with tilt control, you must realize that

the range of sharpness can be extended only in one plane and in a flat plane only. That means that you have no problem obtaining unlimited sharpness across a flat field, a flat landscape or across a table top set up consisting of flat copy material. However, the sharpness range does not cover objects that protrude in the other direction (vertically) such as a tree or house in the landscape, or a vase with flowers in the table top set-up. The bottom of the vertical object is sharp, but not necessarily the top. If you also want the top to be sharp (as you probably do), you must try to do it with the depth of field; that is, by closing down the lens aperture.

Without the special equipment mentioned above, the sharpness range can sometimes be increased by photographing from a different angle, or higher angle when photographing a flat landscape or flat copy. Photographed from a low angle, the flat field or copy is almost rectangular to the film-plane, providing the minimum sharpness range. From a higher angle, the film plane becomes more parallel to the landscape or copy and provides a greater sharpness range. As an example, for a table top set-up photographed from a low, 20

The narrow sharpness range of the lens (above, left) can be extended from top to bottom of a flat surface by tilting the film plane (above, right).

In the diagram on the right, depth of field (top) is determined by the lens and lens aperture. Tilting the lens or film plane (bottom) increases the sharpness range without changing the lens aperture.

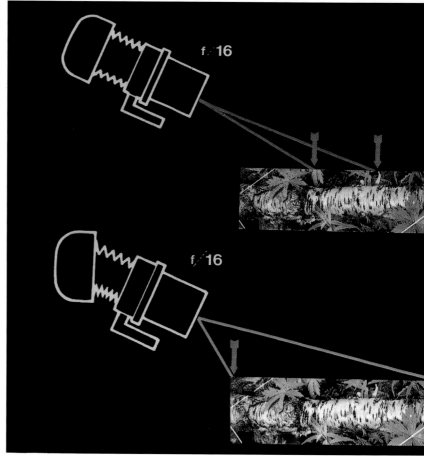

degree angle, you may need a sharpness range from 15 to 40 inches (38cm to 100cm). Photographed from a higher, 40 degree angle, the required sharpness range is reduced to 30 to 40 inches (75cm to 100cm).

■ Selecting the Shutter Speed

In handheld photography, the shutter speed that you want or need may be decided solely by the concern for camera steadiness. In other cases, it may be decided automatically by the desired sharpness range which requires a specific aperture. In still other cases, the shutter speed can and must be determined by the visual effect that we are trying to create. I can think of three situations where this approach should be considered: when photographing subjects that move; when we want to create something special out of a stationary subject by moving the camera, or when attempting to create something different by zooming while the exposure is made.

■ Photographing Moving Subjects

The shutter speed determines how a moving subject is recorded on the film. The most typical example we have all probably seen involves mov-

Personal preference determines whether water should be recorded as we see it with our eyes using a high shutter speed (bottom), or in a more artistic fashion with a slow shutter speed (top).

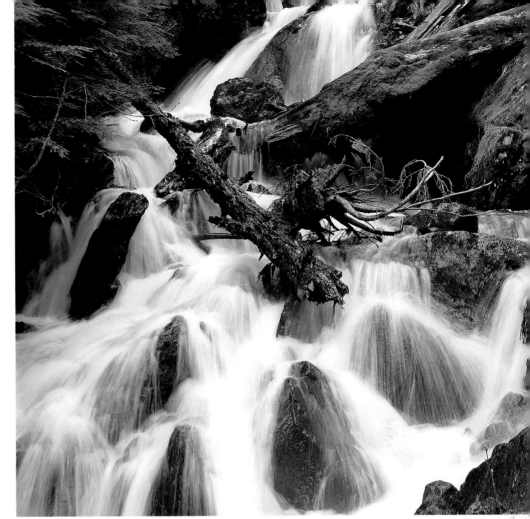

ing water (streams, waterfalls, waves, etc.). At short shutter speeds, even falling water may appear so sharp that we recognize individual water drops. At longer shutter speeds, the moving water is changed into streaks.

Suggested shutter speeds are hard to define since it depends how fast the water moves. Water crashing over rapids or a waterfall may need an exposure as short as 1/2000 sec. to be recorded reasonably sharp – and nothing longer than 1/4 sec. for the blurred effect. For the flowing water in a brook or stream, 1/125 sec. may be short enough to make it appear sharp, but for a good looking blurred effect, you are more likely to succeed with an exposure several seconds long.

Blurred motion in a photographic image is visually effective because blurred motion cannot be seen with our eyes. Moving subjects of any kind appear sharp to us. We can see and recognize children on a moving merry-go-round; we always see a diver, a runner, a moving ice skater or gymnast sharply. The shutter speed gives us a great opportunity to create images that are different from the way we actually see the world. Consider this possibility whenever you take a picture of something that is mov-

ing. Don't limit yourself in this approach to moving water. Wonderful possibilities exist everywhere: in reflections; trees moving in the wind; leaves being blown around by the wind; in sports; sailboats, and even dancers.

■ **Creating Motion Effects**

When subjects do not move (or as an addition to the existing subject movement), we can also create something visually different by moving the camera or changing the focal length of a zoom lens while the image is recorded. Striking images can be created when moving the camera for the purpose of following a moving subject. This is a popular approach in sports photography, especially in car, motorcycle and bicycle races.

"...create something visually different by moving the camera ..."

The visual effect of motion can be especially strong in such cases, as it is created in two different ways. First, the effect comes across visually by the moving camera, which blurs the background. To accentuate the effect, the background must

have details with different shapes and colors (such as spectators). A plain background does not work. The visual effect is further enhanced by the motion in the subject, especially if these movements go in a different direction from the camera movement. This would be the case with the wheels on a bicycle, the legs of a bicycle rider, or the arms and legs of a runner. Shutter speeds for such images range in the neighborhood of 1/2 sec. to 1/8 sec.

A zoom lens allows you to create visually different images by simply changing the focal length (zooming) while the exposure is made. This change of focal length changes the image size and by doing so creates streaks that move one of two ways: from the center out to the picture frame (when the lens is changed from the shorter to the longer focal length), or streaks that move from the outer image area towards the center (when zoomed in the opposite direction). The effect is visually best with subjects of a high contrast (neon signs, for example) and when the streaks appear in front of a dark background. The shutter speed must be long enough to give you time for zooming before the shutter closes – 1/2 sec to 1 sec. is a good choice.

20
SPECIAL EFFECTS FILTERS

The use of filters is usually considered for the purpose of improving the quality of the image. A second possible use of filters is for producing special effects that create a visually more exciting image of an ordinary subject or scene. Many different special effects filters exist that allow you to change colors, produce multiple images, create star effects in the highlights, soften or blur the entire image or part of the image, and achieve other visual manipulations.

These filters offer interesting possibilities for creating something different, but like any other special approach or technique, the result must be visually stimulating. The image must convey the feeling that the use of the filter enhanced the results, and that it was not used just to be different. The special effect must go well with the subject in the picture. I can visualize multiple images, for instance, in pictures of neon signs, pictures taken in an amusement park or on a busy street – but not in a wildlife photograph. The effect of a filter that softens or blurs the outside of the image (leaving the center sharp) can also be interesting and even enhance some images. The softening or blurring, however, should never be done to the point where the effect is so obvious that it becomes the main attention creating element.

"These filters offer interesting possibilities..."

Filters are also available to create the feeling of fog on a clear day. The effect can look rather real if the scene includes only subjects that are more or less at the same distance (a church on the shore of a lake) without any subjects in the foreground. Since all subjects are more or less at the same distance, the density of the fog is the same over the entire picture area. That is the effect that the fog filter produces. If subjects are at different distances in reality, those further away have a heavier fog cover than those in the foreground. The fog filter cannot produce this effect, and the results can look completely unreal. You can also find graduated fog filters that work better when photographing a flat landscape, but they do not help when the foreground consists of vertical subjects such as trees or fences. In a fog filter produced fog scene, the lighting must also look natural. The image should display the soft light associated with an overcast day, or perhaps a faint trace of diffused sunlight.

Ultimately, the effect produced by a special effects filter should also not distract from what the picture is to show. It should add to the composition that we created in the viewfinder.

21

FILMS AND FILM DEVELOPMENT

Other opportunities for making images different, and hopefully more effective, are offered by the use of special films or special development of ordinary films.

What you find here is nothing more than a summary of the most common and simple procedures without going into great detail. It may do nothing more than make you think before you load your camera with film, develop the film or produce the final image.

■ Black and White Infrared Film

Black and white infrared films are sensitive not only to the visible part of the spectrum, but also to the range of infrared radiation.

They are usually used in combination with a color filter (yellow, orange or red), with the red being the recommended choice for most daylight pictures. These filters absorb some of the light from the visible spectrum (especially the blue)

and record the individual colors in different grey tones than do ordinary black and white emulsions. This unique recording of the different colors can make infrared pictures of almost any subject different, beautiful and unique.

"Make images different... by the use of special films."

Study a good book on black and white infrared photography to discover the possibilities and learn special technical details.

One of the details that you may find in the book has to do with focusing. Since the infrared light rays form an image somewhat further from the lens than the visible light, refocusing is recommended for maximum sharpness. Many quality lenses have an infrared focusing index.

If it does, proceed as follows:

1. Focus the lens in the ordinary fashion on the focusing screen of the single lens reflex camera.

2. Read the distance setting opposite the regular focusing index.

3. Set this distance opposite the engraved infrared focusing index.

There are a few apochromatic lenses on the market that are also corrected into the infrared range and do not require an adjustment in the focus setting. The 250mm Sonnar Superachromat on my Hasselblad is one such type.

You can also use infrared black and white film for the purpose of improving distance pictures. Infrared film in combination with a red filter "penetrates" haze and produces the clearest pictures of distant subjects. It also reproduces the blue sky as black and brings out the clouds as no ordinary film can.

Color Infrared Film

Infrared film is also available in some sizes as a color emulsion. While its main application is in scientific and medical fields and in aerial photography, infrared color film is fascinating for color experimentation. Anything you photograph appears in strange and unusual shades. You can enhance the possibilities even further by using any color filter, especially those made for black and white photography (the red, orange, yellows, greens and blues) as well as anything else you find in other shades, such as purple.

With color infrared film, you focus the lens normally since the colors in the visible part of the spectrum are also used for recording the image.

Black and White Transparencies

In the past, black and white images could be projected on the screen only by photographing a black and white print on color transparency film.

Today, it is possible to produce black and white transparencies directly in the camera, using special film such as Agfa Scala. The film can be used for photographing anything under any kind of light, just as you use black and white negative film. This film gives a photographer the wonderful opportunity of presenting the

Unusual colors are created by cross-processing (developing E-6 films in C-41 instead of E-6 developer). Above is the "normal" photograph, and below is the cross-processed image.

black and white creations on the screen in the best possible quality.

The film is also superb for producing black and white transparencies from finished black and white prints. This approach has an advantage in that the projected transparency can include all the print manipulations that may have been made in the darkroom.

The film must be processed specially, so check with the film manufacturer.

High Contrast Black and White Films

Black and white images can also be presented in an unusual fashion by photographing with a high contrast or copy film. Such films record only black and white, without the grey tones in between producing an image that looks more like a line drawing or a graphic design rather than a photograph.

Cross Processing

Anything that you photograph on ordinary color negative or color transparency film can also be presented in different colors through cross processing.

In cross processing, the films are exposed normally, but developed in the "wrong" chemistry. This can mean developing transparency films in C-41 chemistry instead of E-6, or developing negative color films in E-6 instead of C-41. I have found that developing E-6 films in C-41 chemistry produces somewhat more interesting results, but try them both.

Both approaches record subjects of any color in unusual shades, but results are hard to predict and can basically be determined only by experimenting with the technique.

GLOSSARY

Advanced Photo System (APS): A film format, smaller than 35mm, that offers advantages mainly in film loading, printing and storing of images. The images can be recorded in three different formats: standard, wide and panoramic. The smaller format also allows produces more compact cameras.

Aperture: The size of the opening of the lens diaphragm. The maximum aperture of a lens is obtained by dividing the focal length of the lens into its entrance pupil (known to the lens designer).

Bellows: A flexible connection between the camera and lens. It is usually an accessory for 35mm and medium format cameras where it allows moving the lens further from the film plane for close-up photography. A bellows is also a part of most large cameras and some medium format types where it is used for focusing or for shift and tilt control.

Blurred motion: An unsharpness on the film that is caused by either the subject or the camera moving while the shutter is open to produce the image. While unacceptable in most images where the highest quality is required, the blur can also be used effectively to convey the feeling of motion (sports or water, for example). The slower the shutter speed, the more enhanced the effect.

Burning: Increasing the amount of light that hits the photographic paper when making a black and white print. Can be used to darken highlight areas and make them less distracting.

Cable release: An accessory that can be attached to the camera to release the shutter without touching the release button. Recommended when working at longer shutter speeds to reduce the danger of camera movement. Some cable releases have a lock, helpful for very long exposures. A cable release is not needed for hand-held photography.

Color balance: A desirable arrangement of colors within an image.

Color harmony: Refers to the fact that certain colors go with each other better than other colors.

Composition: Means making an effective, pleasing arrangement of lines, shapes and colors within the picture format.

Contrast: Contrast is the difference between the darkness of one tone and another. High contrast occurs when there is a great difference (such as the difference between black & white). Low contrast occurs when there is little difference (such as the difference between medium gray and light gray).

Cropping: Cropping means using only part of the image recorded on the film in order to enlarge part of the image or

to improve the composition. Since only part of the original image is used, image sharpness suffers.

Square images on the film are often changed into verticals or horizontals. This is not the same as cropping. If the long side of the resulting image is the same size as the original square, the image is not enlarged, but simply changed in its shape. This does not result in a loss of image sharpness.

Depth of field: The range of sharpness in front and behind the focused distance that is considered acceptably sharp in the final image. Depth of field is increased by closing the lens aperture. Depth of field is a calculated figure and not dependent on the lens design.

Digital camera: A camera where the image is recorded and stored electronically, not on film. Some medium and large format cameras can be used for digital recording by attaching a digital camera back instead of a rollfilm magazine or a sheet film holder.

Distortion: Refers to anything in the image that does not appear the way it looked to our eyes. Most image distortions are not created by the lens or camera but by the way the camera or lens was used. Image distortions can also be created artificially while the image is made or afterwards. See also Wide angle distortion.

Dodging: Reducing the amount of light which hits the photographic paper when making a black and white print. Results in a brighter shadow area which shows more detail.

Electronic flash: An excellent, bright source of light that can be used alone or in combination with daylight, as both have the same color temperature. A large amount of light can be produced by a small and light-weight unit that can be mounted on the camera. Many cameras have a built-in flash.

Exposure: The amount of light allowed to fall on the film. Specifically, it is the intensity of the light (controlled by the aperture (or f/stop)) multiplied by the duration of time the light hits the film (controlled by the shutter speed).

Exposure meter: A device that measures the light or the subject brightness and gives us the aperture and shutter speed figures. The meter can be built into the camera or can be a separate accessory. See also Incident meter, Reflected meter, Spotmeter and TTL meter.

Fill flash: Light used in addition to the main light to add illumination to dark or shaded areas. Reflectors can be used for this purpose instead of flash.

Film plane: The position of the film in the camera body or film magazine. Focusing distances are always measured from the film plane.

Film sensitivity: Indicates how sensitive the film is to light, and determines the aperture and/or shutter speeds that are necessary to record a properly exposed image on the film. A film with a higher ISO number is more sensitive and therefore recommended in low light levels. See also ISO.

Filter factor: A figure indicating how much light a filter absorbs, thus requiring an increase in exposure when the filter is used. Filter factors are not, however, equivalent to f-stops.

Fisheye lens: A lens that is designed so the angle of view diagonally is much greater (usually 180 degrees) in relation to the angle of view horizontally or vertically. They produce an image with curved lines outside the center area. See also Full frame fisheye lens.

Fixed focus: A lens found in point and shoot cameras that cannot be adjusted for different subject distances. The focal length is usually short and the aperture relatively small so that the depth of field covers a satisfactory distance range with acceptable sharpness.

Focusing range: The minimum and maximum distances at which sharp images can be produced without the use of any accessories.

Focusing screen: In single lens reflex and large format cameras, the image is viewed on a focusing screen rather than an optical viewfinder. On large format and special medium format cameras, the focusing screen is added to the camera in place of the film holder or magazine. On single lens reflex cameras, the mirror projects the image to the focusing screen before the image is made. Focusing screens come in many different versions, also with the addition of micro-prisms, split image rangefinders, checked lines, etc.

Full frame fisheye lens: An image produced in a full frame fisheye lens covers the entire film area. Other fisheye lenses produce a circular image in the center of the film. Full frame fisheye types have wider applications.

Hyperfocal distance: The distance setting on a lens that provides depth of field to infinity at a specific aperture.

Incident meter: An exposure meter that measures the light that falls on the subject that we are photographing. The reading is unaffected by the brightness or color of the subject.

ISO: An international standard to indicate the sensitivity of a film. A higher number means a film with a higher sensitivity, i.e. a faster film.

Large format: Refers to image sizes larger than the medium format, usually 4x5 or 8x10 inches recorded on sheet film.

Lens elements: A single lens within the camera lens. These lens elements may be single components in the lens or they may be cemented together with one or two other lens elements to form a lens component.

Lens plane: The position of the lens in relation to the film plane. The two must normally be parallel to each other. On large format and some medium format cameras, one can be shifted or tilted in relation to the other to increase the range of sharpness or eliminate the need for tilting the camera. Some lenses can accomplish the same.

Macro lens: Usually a lens where the focusing control can be set to much closer distances than on an "ordinary" lens. Such a lens may eliminate the need for close-up accessories. The term "macro" may also refer simply to the fact that such a lens is designed optically to produce the best image quality at close distances.

Medium format: A film format larger than 35mm but not as large as 4x5 inches. It is a film format that should combine some of the benefits and advantages of each. The most popular medium formats are 4.5x6cm, 6x6cm, 6x7cm and 6x8cm. Medium format images are usually recorded on 120 or 220 rollfilm.

Monopod: A single support post for the camera which in some cases can serve the same purpose as a tripod. A monopod is more convenient for carrying and faster in use. A monopod can be equipped with the same heads used on tripods.

Overexposure: Occurs when the amount of light that hits the film is in excess of that needed to produce an accurate representation of the subject on film. The resulting transparency is lighter than desired (the negative is darker).

Panoramic format: An image format that is at least twice as long in one dimension as in the other. Such images can be produced in APS and special panoramic 35mm and medium format cameras. Panoramic images can be produced in some other cameras with masks or special magazines. The final image can also be changed into a panoramic by cropping.

Perspective: The size relationship between subjects at different distances as recorded in the camera. Perspective in a photograph is determined by the camera position, and the distance between the lens and the closest subject.

Perspective control: A feature built into special lenses, tele-converters or cameras that allows moving either the lens or the film in relation to the other. Eliminates or reduces the need for tilting the camera

which would result in slanted lines. Helpful or necessary for architectural work.

Plane of focus: The plane at which the lens is focused.

Print film: Records a negative image on the film, which is then printed on photographic paper as a positive. Such films are available for color and black and white photography.

Reflected meter: An exposure meter that measures the light reflected from the subject we are photographing. Exposure meters built into cameras are of the reflected type. The meter reading is affected by the brightness of the subject.

Sharpness: A visual perception of the amount of detail that is recorded or recognized on the film or the final image. The sharpness of a photographic image is, however, not so much determined by the amount of detail that is visible as the edge sharpness within the subject details.

Shutter: A device that is open a specific length of time to let light go to the image plane. The shutter can be in the camera, usually in front of the image plane (focal plane type), or in the lens.

Shutter speed: The length of time that the shutter in the camera or lens is open to let light travel to the image plane to make the exposure.

SLR camera: A camera type with a mirror that projects the image to the focusing screen for viewing. The mirror moves out of the way for taking the image. SLR (single lens reflex) cameras show the image as recorded on the film. The image can also be viewed at the chosen aperture setting if the camera has a manual stop down control.

Spotmeter: An exposure meter that only measures a small area of the subject. A spotmeter can be built into the camera or be a separate accessory. The area that is measured is clearly indicated on the focusing screen in the camera or in the viewfinder of an accessory spotmeter.

Teleconverter: A lens design that is used together with a camera lens to increase the focal length of the lens. The teleconverter is mounted between the camera and lens. A 2x converter doubles the focal length of the lens, a 1.4x converter lengthens the focal length 1.4x.

Telephoto lens: A lens that has a focal length longer than the standard (50mm for 35mm, 80mm for the 6x6 medium format). Telephoto lenses are usually separated into short telephotos going up to about double the focal length of the standard, and the longer types. A lens of the optically true telephoto design is physically shorter than its focal length. Most long camera lenses are of this design.

Transparency film: Records a positive image on the film, an image where the colors are the same as in reality, where black is recorded as black, and white as white. Such films are available for color and black and white photography.

Tripod: A camera accessory to support the camera for steadier operation than hand held. Necessary or recommended with longer shutter speeds and/or longer focal length lenses.

TTL metering: TTL stands for "Through The Lens." It is usually used in connection with a light metering system that measures the light through the camera lens, or a dedicated flash system that measures the flash reflected from the subject (also through the lens).

Underexposure: Occurs when the amount of light which hits the film is insufficient to produce an accurate representation of the subject on film. The resulting transparency is darker than desired (the negative is lighter).

Viewfinder: The camera component that is used to view the subject (an optical viewfinder) or lets you view the image of the subject on the focusing screen (as on a single reflex camera).

Vignetting: Vignetting is a darkening at the corners and sides of an image to emphasize the

main subject. This effect is common in portraiture.

Vingetting in a picture can also be caused by a filter or lens shade that is too small for the focal length and/or diameter of the lens, or by shifting a lens beyond its covering power. Some wide angle lenses (and especially some extreme wide angle lenses) also exhibit a darkening on the corners, mainly created because some light rays enter the lens at very steep angles and are partially absorbed. Central neutral density filters are used to compensate for the difference in illumination on such lenses.

Wide angle distortion: Wide angle distortion refers to three dimensional subjects being recorded distorted (elongated) an the edges or corners of an image, especially when made with wide angle lenses on any camera. Mainly caused because the film plane is flat. Definitely not a fault in the wide angle lens design.

Wide angle lens: A lens with a focal length shorter than the standard. There are two optically different wide angle lens designs. An optically true wide angle design lens must be close to the film plane and can therefore not be used on SLR cameras. Such lenses are used on large format and some special cameras made for smaller formats. A retrofocus wide angle lens is necessary for SLR cameras.

Zoom effects: Produced by changing the focal length (zooming) while the image is recorded on the film. Zooming changes the image size while the subject or scene is recorded, producing a streaking effect on the film.

Zoom lens: A lens design where the focal length can be changed within a certain range by moving some of the lens elements. The range of focal lengths is called the zoom range. True zoom lenses stay in focus when the focal length is changed. Some zoom lenses, especially those made for projectors, require re-focusing.

INDEX

Other Books from
Amherst Media, Inc.

Basic 35mm Photo Guide

Craig Alesse

Great for beginning photographers! Designed to teach 35mm basics step-by-step — completely illustrated. Features the latest cameras. Includes: 35mm automatic, semi-automatic cameras, camera handling, f-stops, shutter speeds, and more! $12.95 list, 9x8, 112p, 178 photos, order no. 1051.

Into Your Darkroom Step-by-Step

Dennis P. Curtin

This is the ideal beginning darkroom guide. Easy to follow and fully illustrated each step of the way. Includes information on: the equipment you'll need, set-up, making proof sheets and much more! $17.95 list, 8½x11, 90p, hundreds of photos, order no. 1093.

Wedding Photographer's Handbook

Robert and Sheila Hurth

A complete step-by-step guide to succeeding in the world of wedding photography. Packed with shooting tips, equipment lists, must-get photo lists, business strategies, and much more! $24.95 list, 8½x11, 176p, index, b&w and color photos, diagrams, order no. 1485.

Lighting for People Photography, 2nd ed.

Stephen Crain

The up-to-date guide to lighting. Includes: set-ups, equipment information, strobe and natural lighting, and much more! Features diagrams, illustrations, and exercises for practicing the techniques discussed in each chapter. $29.95 list, 8½x11, 120p, b&w and color photos, glossary, index, order no. 1296.

Camera Maintenance & Repair Book 1

Thomas Tomosy

A step-by-step, illustrated guide by a master camera repair technician. Includes: testing camera functions, general maintenance, basic tools needed and where to get them, basic repairs for accessories, camera electronics, plus "quick tips" for maintenance and more! $29.95 list, 8½x11, 176p, order no. 1158.

Camera Maintenance & Repair Book 2

Thomas Tomosy

Build on the basics covered Book 1, with advanced techniques. Includes: mechanical and electronic SLRs, zoom lenses, medium format cameras, and more. Features models not included in the Book 1. $29.95 list, 8½x11, 176p, 150+ photos, charts, tables, appendices, index, glossary, order no. 1558.

Restoring the Great Collectible Cameras (1945-70)

Thomas Tomosy

More step-by-step instruction on how to repair collectible cameras. Covers postwar models (1945-70). Hundreds of illustrations show disassembly and repair. $29.95 list, 8½x11, 128p, 200+ photos, index, order no. 1573.

Leica Camera Repair Handbook

Thomas Tomosy

A detailed technical manual for repairing Leica cameras. Each model is discussed individually with step-by-step instructions. Exhaustive photographic illustration ensures that every step of the process is easy to follow. $39.95 list, 8½x11, 128p, 130 b&w photos, appendix, order no. 1641.

Outdoor and Location Portrait Photography

Jeff Smith

Learn how to work with natural light, select locations, and make clients look their best. Step-by-step discussions and helpful illustrations teach you the techniques you need to shoot outdoor portraits like a pro! $29.95 list, 8½x11, 128p, b&w and color photos, index, order no. 1632.

Guide to International Photographic Competitions

Dr. Charles Benton

Remove the mystery from international competitions with all the information you need to select competitions, enter your work, and use your results for continued improvement and further success! $29.95 list, 8½x11, 120p, b&w photos, index, appendices, order no. 1642.

Freelance Photographer's Handbook

Cliff & Nancy Hollenbeck

Whether you want to be a freelance photographer or are looking for tips to improve your current freelance business, this volume is packed with ideas for creating and maintaining a successful freelance business. $29.95 list, 8½x11, 107p, 100 b&w and color photos, index, glossary, order no. 1633.

Infrared Landscape Photography

Todd Damiano

Landscapes shot with infrared can become breathtaking images. The author analyzes over fifty of his most compelling photographs to teach you the techniques you need to capture landscapes with infrared. $29.95 list, 8½x11, 120p, b&w photos, index, order no. 1636.

Wedding Photography: Creative Techniques for Lighting and Posing

Rick Ferro

Creative techniques for lighting and posing wedding portraits that will set your work apart from the competition. Covers every phase of wedding photography. $29.95 list, 8½x11, 128p, b&w and color photos, index, order no. 1649.

Professional Secrets of Advertising Photography

Paul Markow

No-nonsense information for those interested in the business of advertising photography. Includes: how to catch the attention of art directors, make the best bid, and produce the high-quality images your clients demand. $29.95 list, 8½x11, 128p, 80 photos, index, order no. 1638.

Lighting Techniques for Photographers

Norm Kerr

This book teaches you to predict the effects of light in the final image. It covers the interplay of light qualities, as well as color compensation and manipulation of light and shadow. $29.95 list, 8½x11, 120p, 150+ color and b&w photos, index, order no. 1564.

Infrared Photography Handbook

Laurie White

Covers black and white infrared photography: focus, lenses, film loading, film speed rating, batch testing, paper stocks, and filters. Black & white photos illustrate how IR film reacts. $29.95 list, 8½x11, 104p, 50 b&w photos, charts & diagrams, order no. 1419.

How to Shoot and Sell Sports Photography

David Arndt

A step-by-step guide for amateur photographers, photojournalism students and journalists seeking to develop the skills and knowledge necessary for success in the demanding field of sports photography. $29.95 list, 8½x11, 120p, 111 photos, index, order no. 1631.

How to Operate a Successful Photo Portrait Studio

John Giolas

Combines photographic techniques with practical business information to create a complete guide book for anyone interested in developing a portrait photography business (or improving an existing business). $29.95 list, 8½x11, 120p, 120 photos, index, order no. 1579.

Fashion Model Photography

Billy Pegram

For the photographer interested in shooting commercial model assignments, or working with models to create portfolios. Includes techniques for dramatic composition, posing, selection of clothing, and more! $29.95 list, 8½x11, 120p, 58 photos, index, order no. 1640.

Computer Photography Handbook

Rob Sheppard

Learn to make the most of your photographs using computer technology! From creating images with digital cameras, to scanning prints and negatives, to manipulating images, you'll learn all the basics of digital imaging. $29.95 list, 8½x11, 128p, 150+ photos, index, order no. 1560.

Achieving the Ultimate Image

Ernst Wildi

Ernst Wildi teaches the techniques required to take world class, technically flawless photos. Features: exposure, metering, the Zone System, composition, evaluating an image, and more! $29.95 list, 8½x11, 128p, 120 b&w and color photos, index, order no. 1628.

Black & White Portrait Photography

Helen Boursier

Make money with b&w portrait photography. Learn from top b&w shooters! Studio and location techniques, with tips on preparing your subjects, selecting settings and wardrobe, lab techniques, and more! $29.95 list, 8½x11, 128p, 130+ photos, index, order no. 1626

Stock Photography

Ulrike Welsh

This book provides an inside look at the business of stock photography. Explore photographic techniques and business methods that will lead to success shooting stock photos — creating both excellent images and business opportunities. $29.95 list, 8½x11, 120p, 58 photos, index, order no. 1634.

Profitable Portrait Photography

Roger Berg

A step-by-step guide to making money in portrait photography. Combines information on portrait photography with detailed business plans to form a comprehensive manual for starting or improving your business. $29.95 list, 8½x11, 104p, 100 photos, index, order no. 1570

Professional Secrets for Photographing Children

Douglas Allen Box

Covers every aspect of photographing children on location and in the studio. Prepare children and parents for the shoot, select the right clothes capture a child's personality, and shoot story book themes. $29.95 list, 8½x11, 128p, 74 photos, index, order no. 1635.

Handcoloring Photographs Step-by-Step

Sandra Laird & Carey Chambers

Learn to handcolor photographs step-by-step with the new standard in handcoloring reference books. Covers a variety of coloring media and techniques with plenty of colorful photographic examples. $29.95 list, 8½x11, 112p, 100+ color and b&w photos, order no. 1543.

Special Effects Photography Handbook

Elinor Stecker Orel

Create magic on film with special effects! Little or no additional equipment required, use things you probably have around the house. Step-by-step instructions guide you through each effect. $29.95 list, 8½x11, 112p, 80+ color and b&w photos, index, glossary, order no. 1614.

McBroom's Camera Bluebook, 6th ed.

Mike McBroom

Comprehensive and fully illustrated, with price information on: 35mm, digital, APS, underwater, medium & large format cameras, exposure meters, strobes and accessories. Pricing info based on equipment condition. A must for any camera buyer, dealer, or collector! $29.95 list, 8½x11, 336p, 275+ photos, order no. 1553.

Fine Art Portrait Photography

Oscar Lozoya

The author examines a selection of his best photographs, and provides detailed technical information about how he created each. Lighting diagrams accompany each photograph. $29.95 list, 8½x11, 128p, 58 photos, index, order no. 1630.

Family Portrait Photography

Helen Boursier

Learn from professionals how to operate a successful portrait studio. Includes: marketing family portraits, advertising, working with clients, posing, lighting, and selection of equipment. Includes images from a variety of top portrait shooters. $29.95 list, 8½x11, 120p, 123 photos, index, order no. 1629.

The Art of Infrared Photography, *4th Edition*

Joe Paduano

A practical guide to the art of infrared photography. Tells what to expect and how to control results. Includes: anticipating effects, color infrared, digital infrared, using filters, focusing, developing, printing, handcoloring, toning, and more! $29.95 list, 8½x11, 112p, order no. 1052

The Art of Portrait Photography

Michael Grecco

Michael Grecco reveals the secrets behind his dramatic portraits which have appeared in magazines such as *Rolling Stone* and *Entertainment Weekly*. Includes: lighting, posing, creative development, and more! $29.95 list, 8½x11, 128p, order no. 1651.

Essential Skills for Nature Photography

Cub Kahn

Learn all the skills you need to capture landscapes, animals, flowers and the entire natural world on film. Includes: selecting equipment, choosing locations, evaluating compositions, filters, and much more! $29.95 list, 8½x11, 128p, order no. 1652.

Photographer's Guide to Polaroid Transfer

Christopher Grey

Step-by-step instructions make it easy to master Polaroid transfer and emulsion lift-off techniques and add new dimensions to your photographic imaging. Fully illustrated every step of the way to ensure good results the very first time! $29.95 list, 8½x11, 128p, order no. 1653.

Black & White Landscape Photography

John Collett and David Collett

Master the art of b&w landscape photography. Includes: selecting equipment (cameras, lenses, filters, etc.) for landscape photography, shooting in the field, using the Zone System, and printing your images for professional results. $29.95 list, 8½x11, 128p, order no. 1654.

Creative Lighting Techniques for Studio Photographers

Dave Montizambert

Master studio lighting and gain complete creative control over your images. Whether you are shooting portraits, cars, table-top or any other subject, Dave Montizambert teaches you the skills you need to confidently create with light. $29.95 list, 8½x11, 120p, order no. 1666.

Wedding Photojournalism

Andy Marcus

Learn the art of creating dramatic unposed wedding portraits. Working through the wedding from start to finish you'll learn where to be, what to look for and how to capture it on film. A hot technique for contemporary wedding albums! $29.95 list, 8½x11, 128p, order no. 1656.

Storytelling Wedding Photography

Barbara Box

Barbara and her husband shoot as a team at weddings. Here, she shows you how to create outstanding candids (which are her specialty), and combine them with formal portraits (her husband's specialty) to create a unique wedding album. $29.95 list, 8½x11, 128p, order no. 1667.

Studio Portrait Photography of Children and Babies

Marilyn Sholin

Learn to work with the youngest portrait clients to create images that will be treasured for years to come. Includes tips for working with kids at every developmental stage, from infant to pre-schooler. Features: lighting, posing and much more! $29.95 list, 8½x11, 128p, order no. 1657.

Fine Art Children's Photography

Doris Carol Doyle

Learn to create fine art portraits of children in black & white. Included is information on: posing, lighting for studio portraits, shooting on location, clothing selection, working with kids and parents, and much more! $29.95 list, 8½x11, 128p, order no. 1668.

Professional Secrets of Wedding Photography

Douglas Allen Box

Over fifty top-quality portraits are individually analyzed to teach you the art of professional wedding portraiture. Lighting diagrams, posing information and technical specs are included for every image. $29.95 list, 8½x11, 128p, order no. 1658.

Infrared Portrait Photography

Richard Beitzel

Discover the unique beauty of infrared portraits, and learn to create them yourself. Included is information on: shooting with infrared, selecting subjects and settings, filtration, lighting, and much more! $29.95 list, 8½x11, 128p, order no. 1669.

Photographer's Guide to Shooting Model & Actor Portfolios

CJ Elfont, Edna Elfont and Alan Lowy

Learn to create outstanding images for actors and models looking for work in fashion, theater, television, or the big screen. Includes the business, photographic and professional information you need to succeed! $29.95 list, 8½x11, 128p, order no. 1659.

Black & White Photography for 35mm

Richard Mizdal

A guide to shooting and darkroom techniques! Perfect for beginning or intermediate photographers who wants to improve their skills. Features helpful illustrations and exercises to make every concept clear and easy to follow. $29.95 list, 8½x11, 128p, order no. 1670.

Photo Retouching with Adobe® Photoshop®

Gwen Lute

Designed for photographers, this manual teaches every phase of the process, from scanning to final output. Learn to restore damaged photos, correct imperfections, create realistic composite images and correct for dazzling color. $29.95 list, 8½x11, 120p, order no. 1660.

Secrets of Successful Aerial Photography

Richard Eller

Learn how to plan for every aspect of a shoot and take the best possible images from the air. Discover how to control camera movement, compensate for environmental conditions and compose outstanding aerial images. $29.95 list, 8½x11, 120p, order no. 1679.

Professional Secrets of Nature Photography

Judy Holmes

Improve your nature photography with this must-have book. Covers every aspect of making top-quality images, from selecting the right equipment, to choosing the best subjects, to shooting techniques for professional results every time. $29.95 list, 8½x11, 120p, order no. 1682.

Macro and Close-up Photography Handbook

Stan Sholik

Learn to get close and capture breathtaking images of small subjects – flowers, stamps, jewelry, insects, etc. Designed with the 35mm shooter in mind, this is a comprehensive manual full of step-by-step techniques. $29.95 list, 8½x11, 120p, order no. 1686.

Outdoor and Survival Skills for Nature Photographers

Ralph LaPlant and Amy Sharpe

An essential guide for photographing outdoors. Learn all the skills you need to have a safe and productive shoot – from selecting equipment, to finding subjects, to preventing (or dealing with) injury and accidents. $17.95 list, 8½x11, 80p, order no. 1678.

Infrared Wedding Photography

Patrick Rice, Barbara Rice & Travis Hill

Step-by-step techniques for adding the dreamy look of black & white infrared to your wedding portraiture. Capture the fantasy of the wedding with unique ethereal portraits your clients will love! $29.95 list, 8½x11, 128p, order no. 1681.

Practical Manual of Captive Animal Photography

Michael Havelin

Learn the environmental and preservational advantages of photographing animals in captivity – as well as how to take dazzling, natural-looking photos of captive subjects (in zoos, preserves, aquariums, etc.). $29.95 list, 8½x11, 120p, order no. 1683.

Innovative Techniques for Wedding Photography

David Arndt

Spice up your wedding photography (and attract new clients) with dozens of creative techniques from top-notch professional wedding photographers! $29.95 list, 8½x11, 120p, order no. 1684.

Dramatic Black & White Photography:
Shooting and Darkroom Techniques

J.D. Hayward

Create dramatic fine-art images and portraits with the master b&w techniques in this book. From outstanding lighting techniques to top-notch, creative darkroom work, this book takes b&w to the next level! $29.95 list, 8½x11, 128p, order no. 1687.

Photographing Your Artwork

Russell Hart

A step-by-step guide for taking high-quality slides of artwork for submission to galleries, magazines, grant committees, etc. Learn the best photographic techniques to make your artwork (be it 2D or 3D) look its very best! $29.95 list, 8½x11, 128p, order no. 1688.

Studio Portrait Photography in Black & White

David Derex

From concept to presentation, you'll learn how to select clothes, create beautiful lighting, prop and pose top-quality black & white portraits in the studio. $29.95 list, 8½x11, 128p, order no. 1689.